To the memory of my mother,
who dearly loved these hills.

Warmest gratitude is
extended to all those who
allowed inclusion of their
personal contributions – be they
home, garden, farm or other
work place – to the vital
diversity that we celebrate
as Litchfield County.

Special thanks to Jack Flannery
of Ridge Typographers, Betsy
Dassau of Danbury Printing &
Litho, and Mary Jones of
DS Color Graphics for their
invaluable collaboration.

A Glance At Litchfield County.

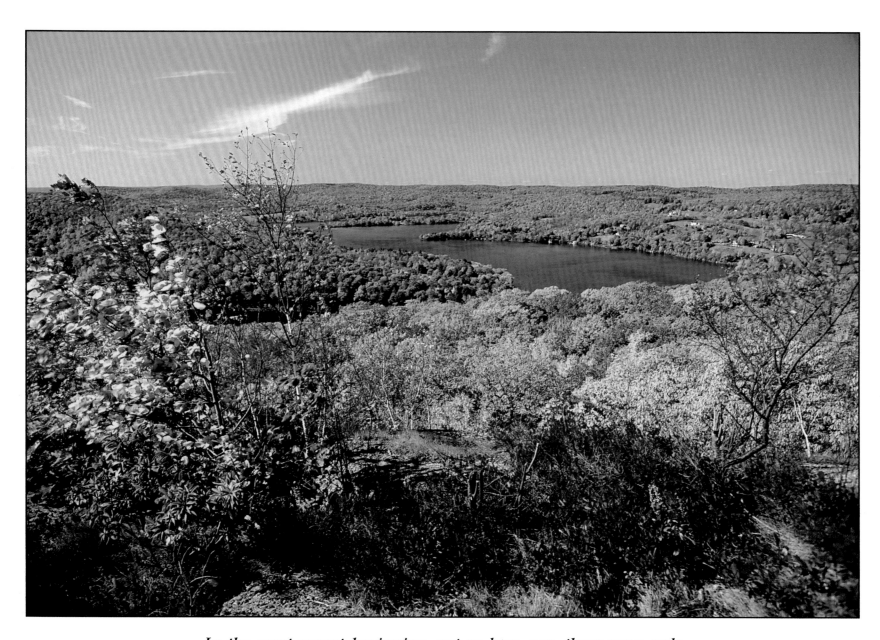

In the most recent beginning, not so long ago, there were only glaciers, great groaning ice flows that shouldered their way southward through and over this land. Their passing left a vertical dimension unique in Connecticut: hills and valleys of graceful sweep and high prominence. Here Lake Waramaug stretches away from the Pinnacle in New Preston, an outlook that commands a view of most of the county . . . and beyond.

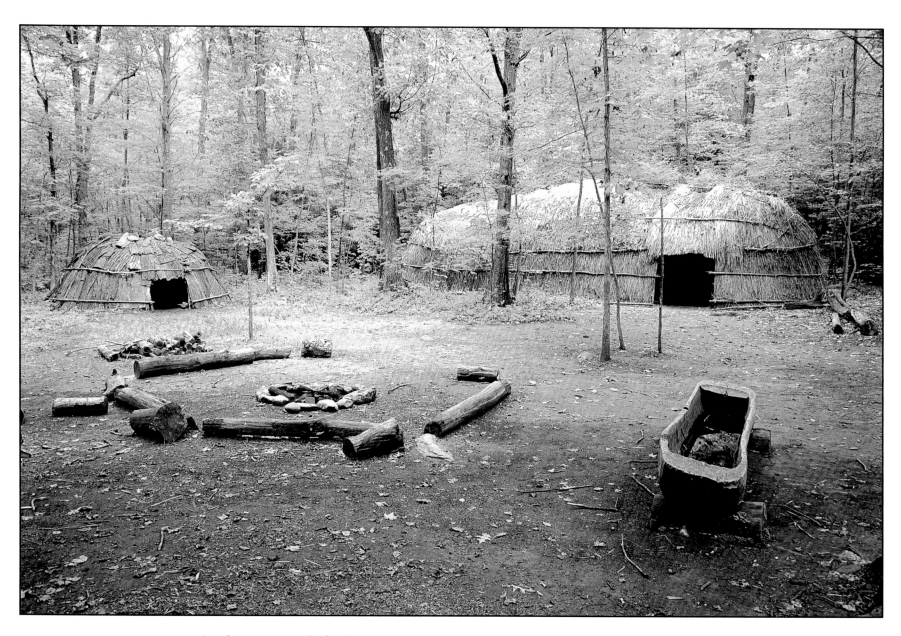

As the ice receded, Man advanced, finding a legacy of water that has encouraged life and diversity ever since. The first settlers have a long, enduring history requiring volumes to relate, plus a visit to Washington's Institute for American Indian Studies, where can be found this replica of an Algonkian village of some thousand years ago.

An association seldom made in New England involves the ubiquitous stone walls and the first Americans. These masterful examples in North Cornwall were most likely created by Schaticoke tribesmen, as were many throughout the region.

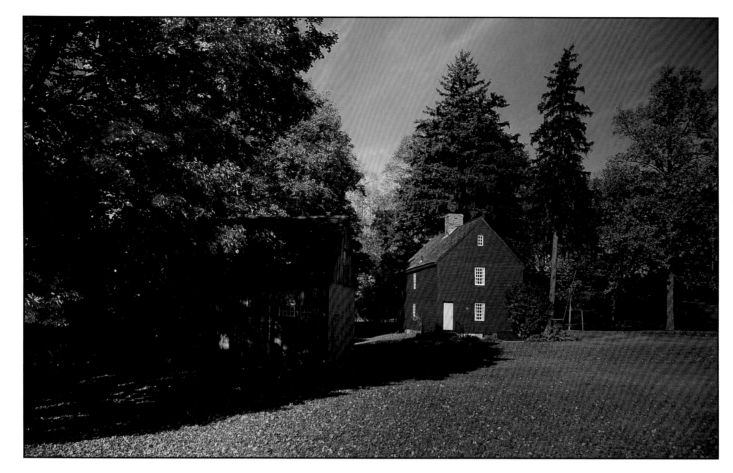

With the coming of European settlers, structures of greater durability than bark and tree branch, though not so much as stone, made their appearance. Few remain. Among the oldest is Hurd House, dating from 1680, that nestles in The Hollow, Woodbury's first settlement.

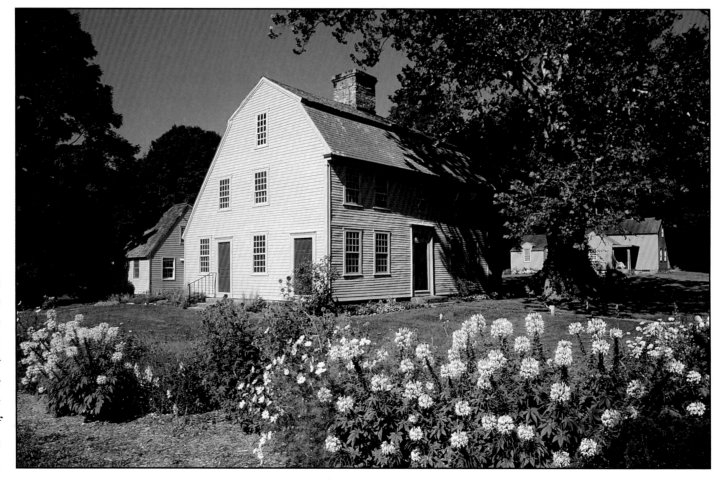

Close by, though several decades younger, is Glebe House, now a museum that boasts historic gardens and being the birthplace of American Episcopacy.

The Logan Homestead, in Washington, has been in the same family since the First President was a boy. It served weary travellers as an inn for several generations and is now again the family gathering place.

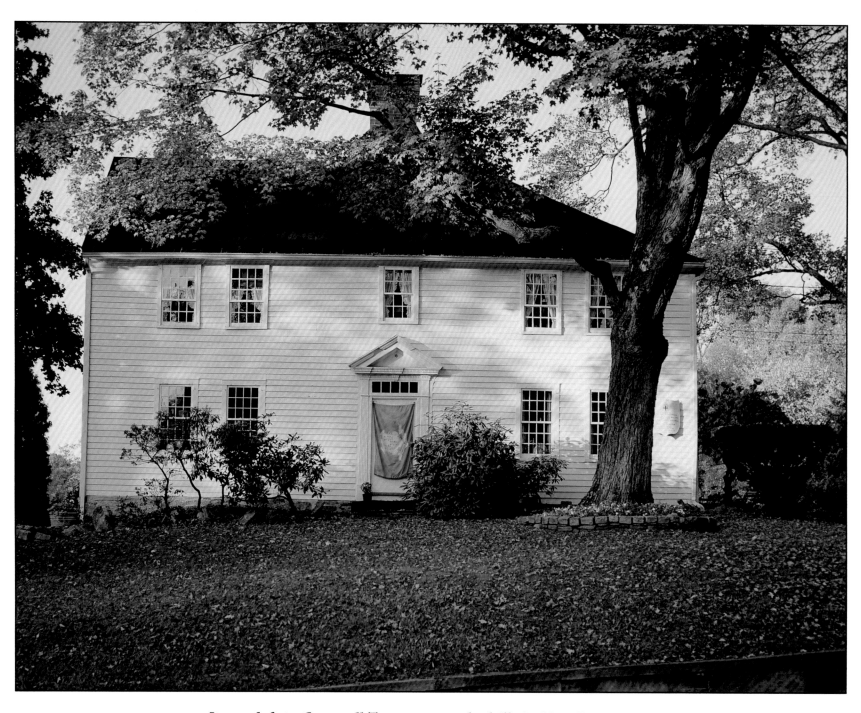

It was left to Cogswell Tavern, over the hills in New Preston, to serve as George Washington's local stop-over. This venerable home also boasts continuous family ownership for more than two and a half centuries.

There are many fine examples of early colonial homes still extant in the county. Just one such is this 1730's saltbox with its hallmark central chimney, recently renovated in Bethlehem.

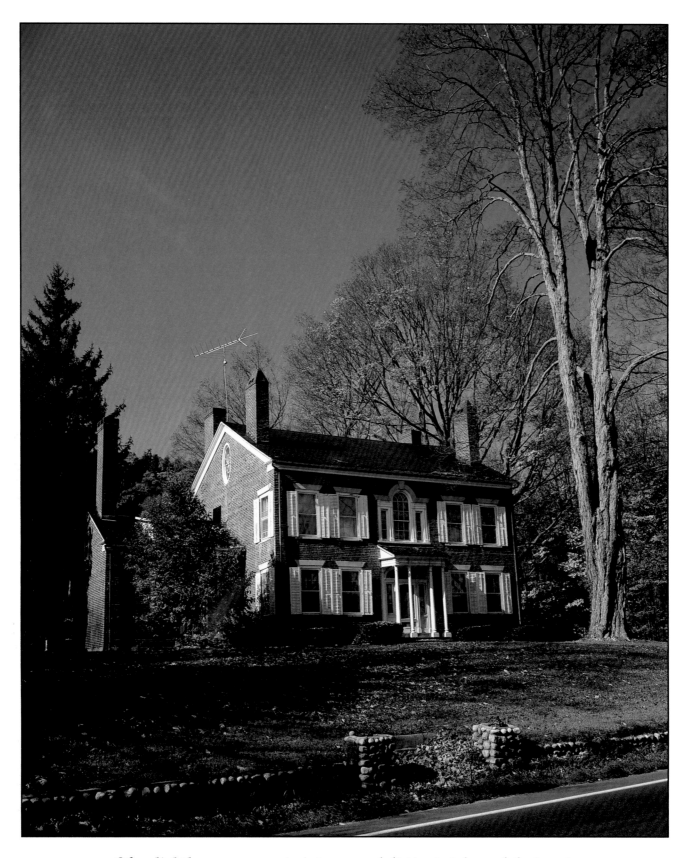

Of a slightly more recent vintage, and distinct style and design, is this remarkable brick residence, rare for the area, south of New Milford. It dates from the late 1700's and has seen more than its share of change along Route 7.

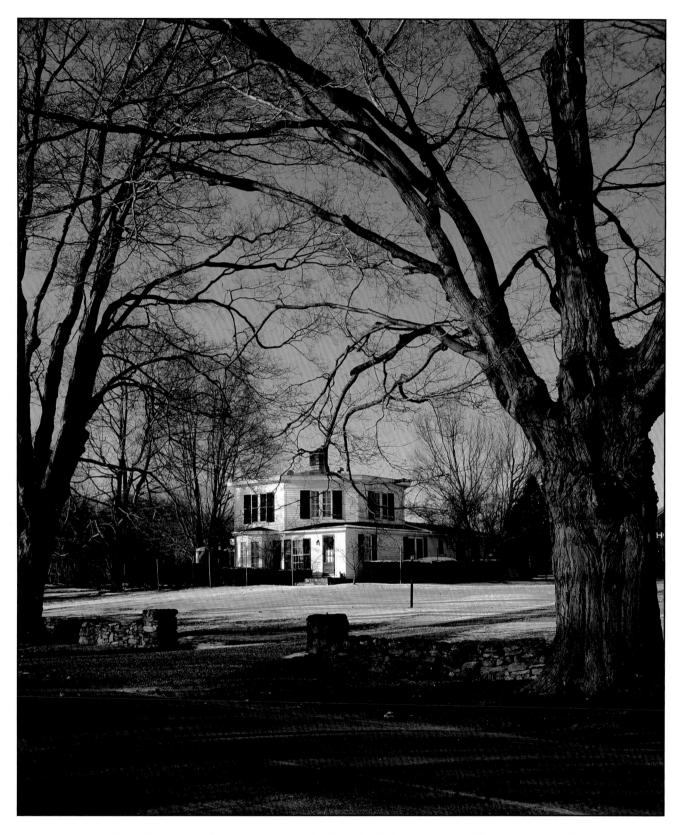

A striking architectural variation is this octagonal home, one of two built in Washington in the mid 1800's. The majestic row of sugar maples still stand guard here, marking a lot line that dates to the 1700's.

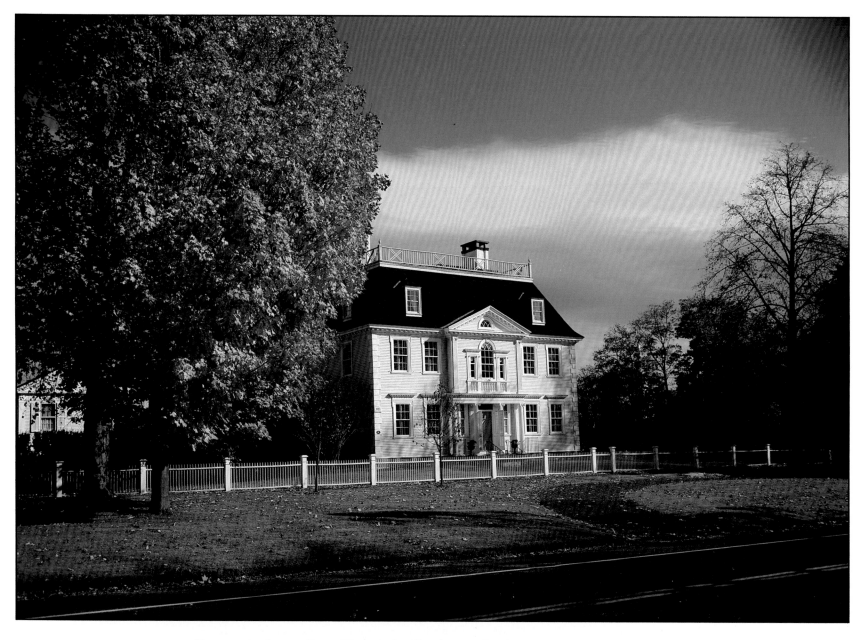

Representing what Kenneth Clark might have called a sense of confidence and accomplishment, this home exemplifies the full splendor of residences along Litchfield's North and South Streets.

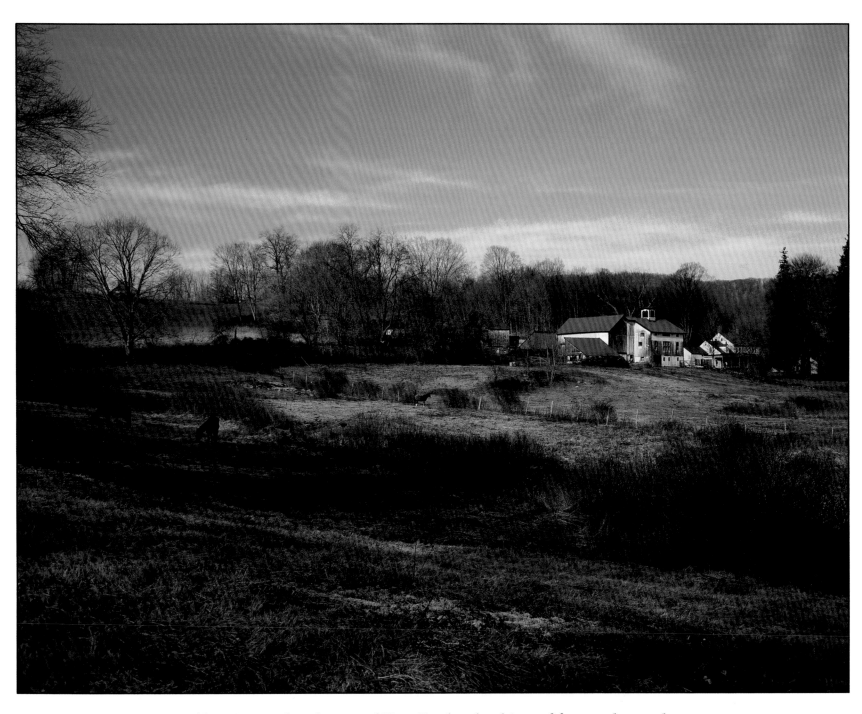

Turning to the elemental New England subject of farms, the stark-ness of low winter light illumines the challenge of wresting a living from the soil along Bee Brook in Washington.

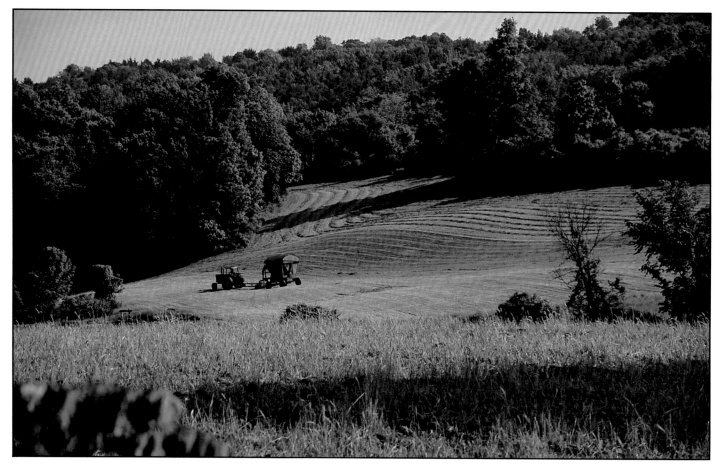

Much of the land kept cleared today — a fraction of the 90% of total in 1840 — remains fertile and worked in spite of slant or slope.

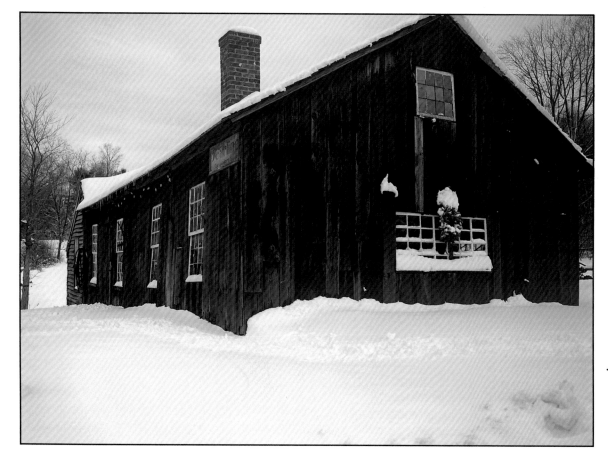

Wherever farms sprang up, or horsemen passed, there came a need for blacksmiths, the tool makers as well as farriers of each community. This smithy still stands in Bakersville as one of its oldest buildings, dating from the 1820's.

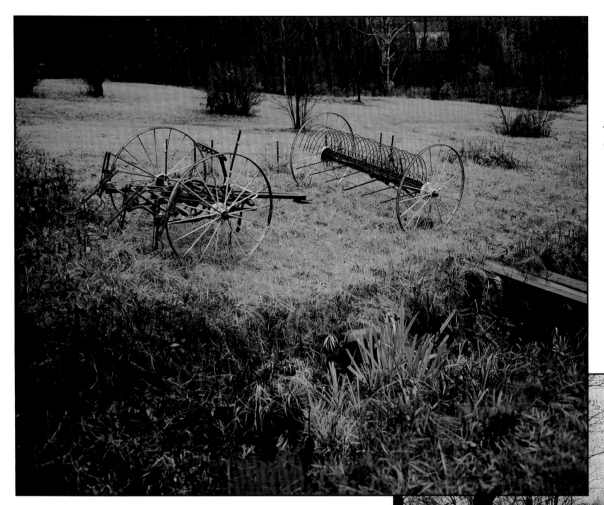

Nearby stand some of the pride of the products of their day.

In Barkhamstead can be found further evidence of early Yankee ingenuity: components of a vertical power saw that predates the circular.

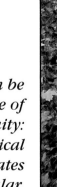

Most of the past has sunk back into the land, but here and there the process of "recall" is caught in mid-cycle, as with these barns along the Housatonic River, not long ago.

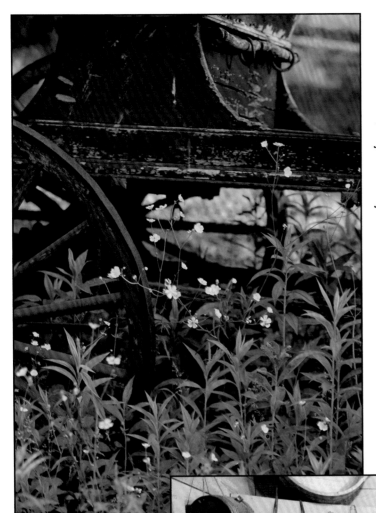

For those unusually fortunate in their meanderings, the past can pop up out of fields of buttercups, as here near Cornwall Bridge.

Slightly down river, in Kent along Route 7, can be found one of the county's most be-loved museums, the Sloan-Stanley, where early American tools of every description are on display, from late spring to fall. (Photo courtesy of The Sloan-Stanley Museum.)

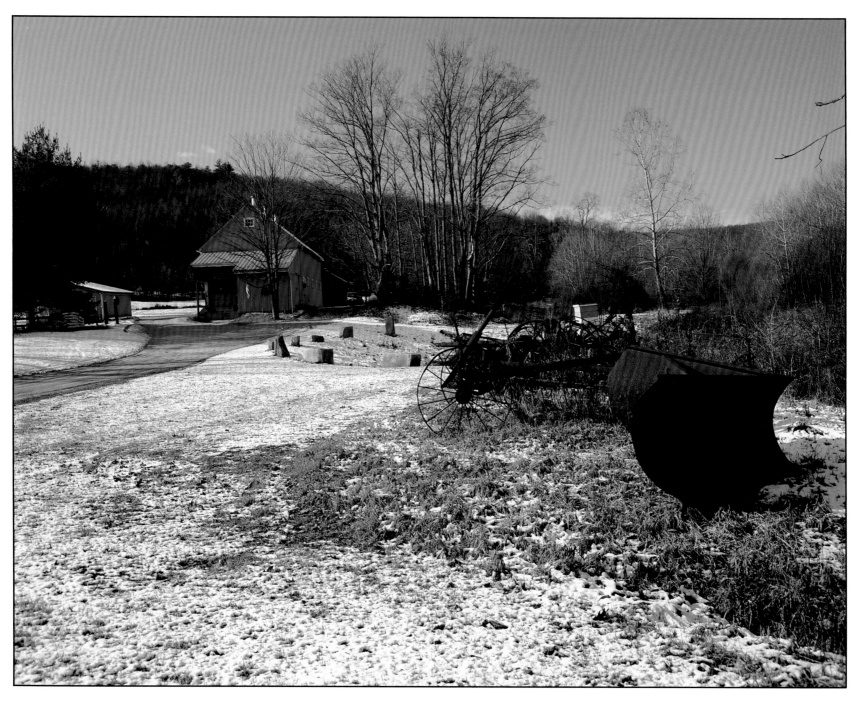

The entire area serves as a museum, however, as this farm in Roxbury attests.

Some farms, such as here in Goshen, take on the appearance of post-modern galleries, along with all else.

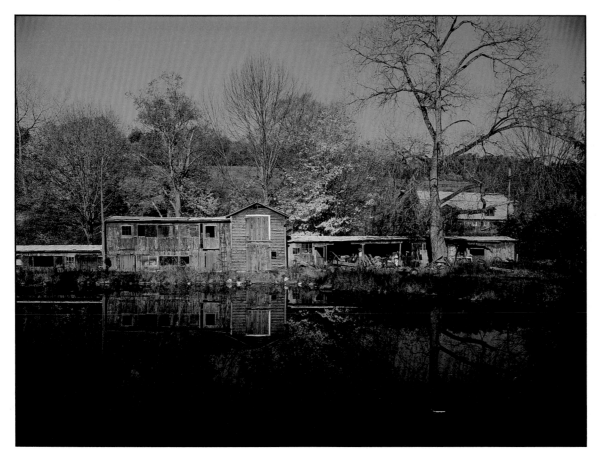

Transition draws the eye from every roadside. This chicken house in Roxbury bears witness to many autumns as it prepares to slip back into the landscape.

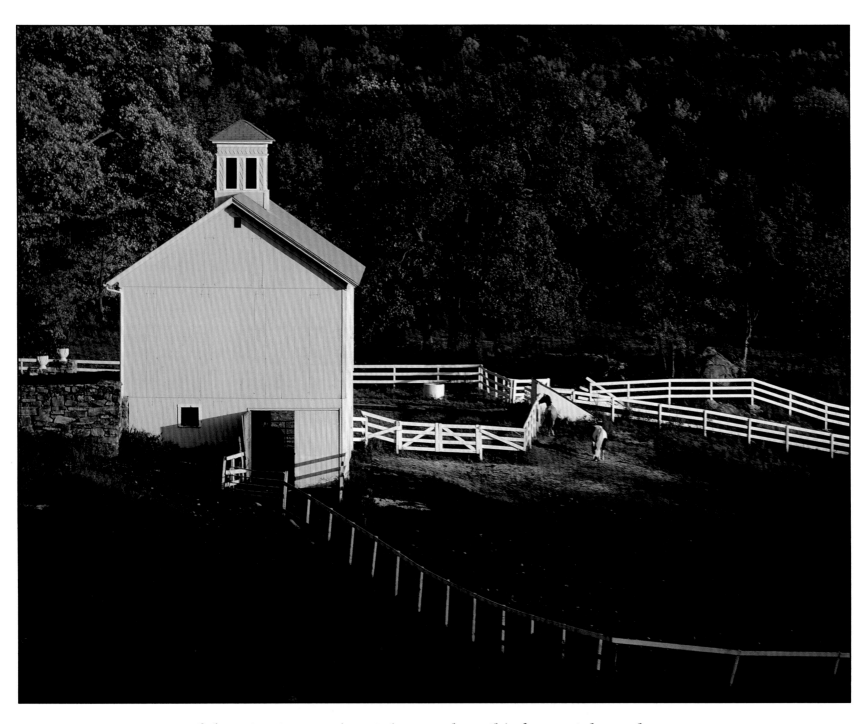

*Other structures gain reprieve, such as this former tobacco barn
given new life and an imaginative look in New Preston.*

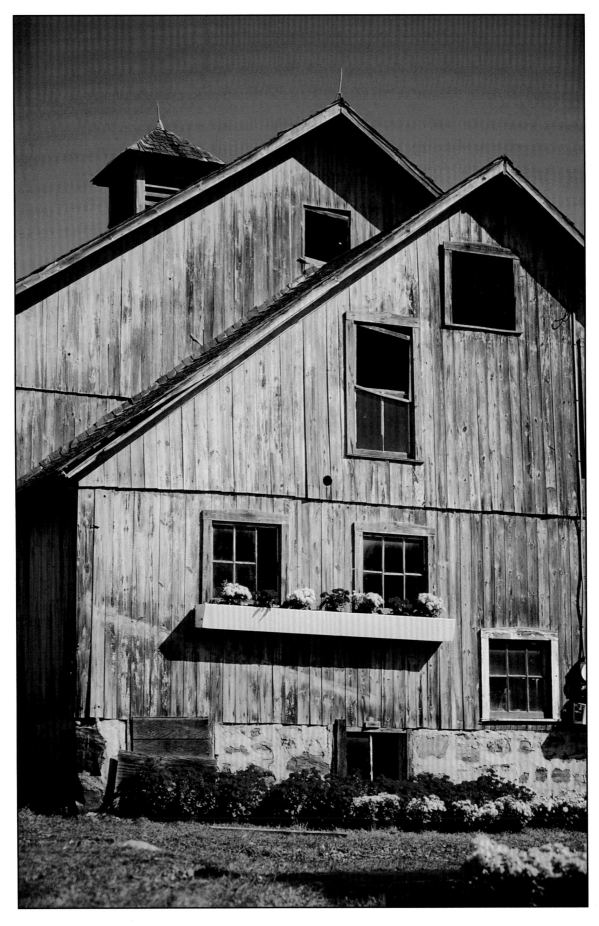

Some barns benefit from the ageing process, as does this great gray in Northfield, now a perfect off-set for the autumnal colors it displays.

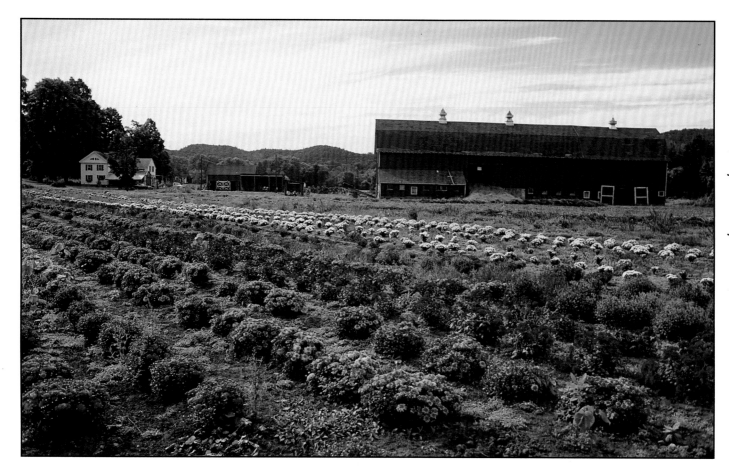

Frequently today's farms turn to new and varied crops, bringing back the farm stand with them, as with this thriving concern in Limerock.

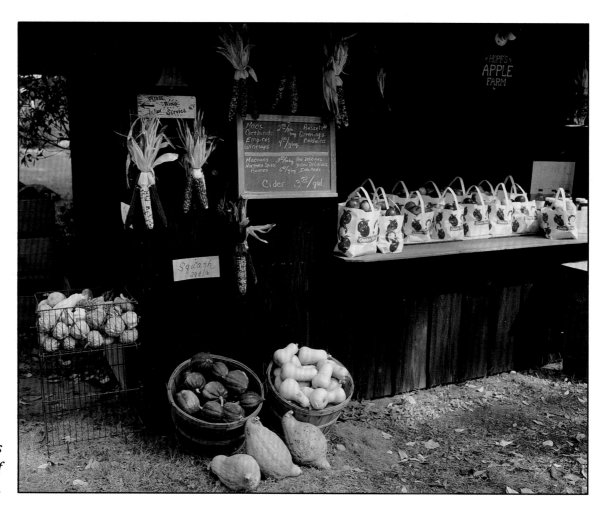

This East Cornwall stand speaks in eloquent tones and shades of fields not far from view.

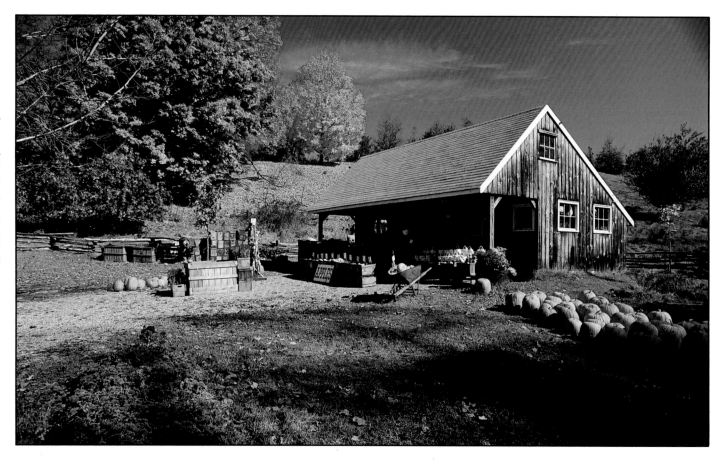

This popular Roxbury example, built from wood milled by the family members who planted the trees, operates on a farm that dates to 1740.

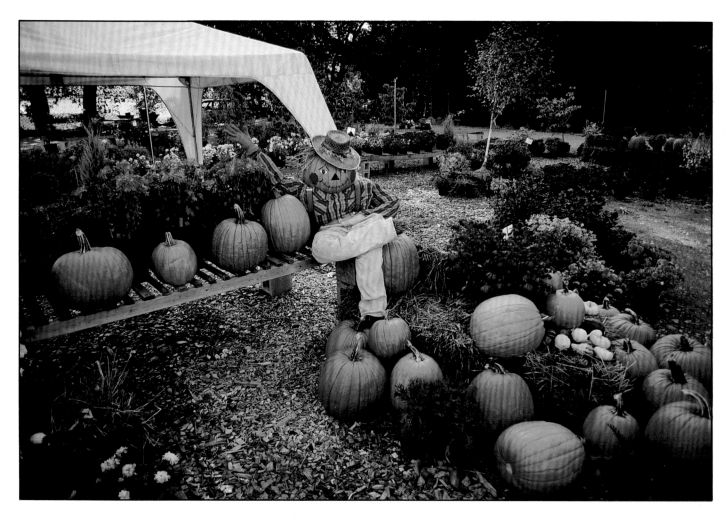

Throughout the county, plant life and produce are readily, often eye-catchingly, available, as here in Hotchkissville.

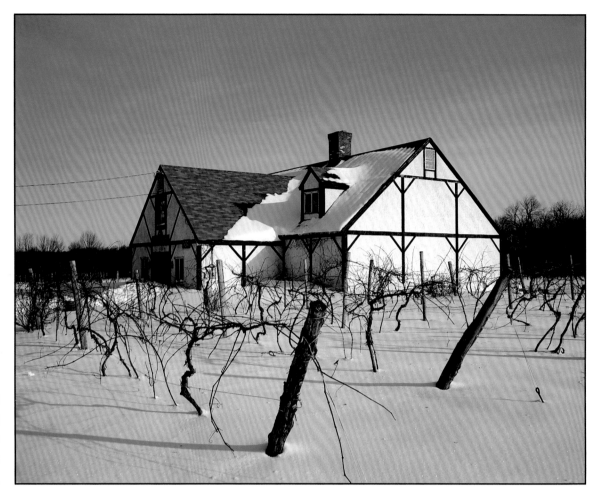

As a serious alternate crop, the grape (and wine making) has become a viable pursuit for a few regional farms, including these in Litchfield (top) and Warren.

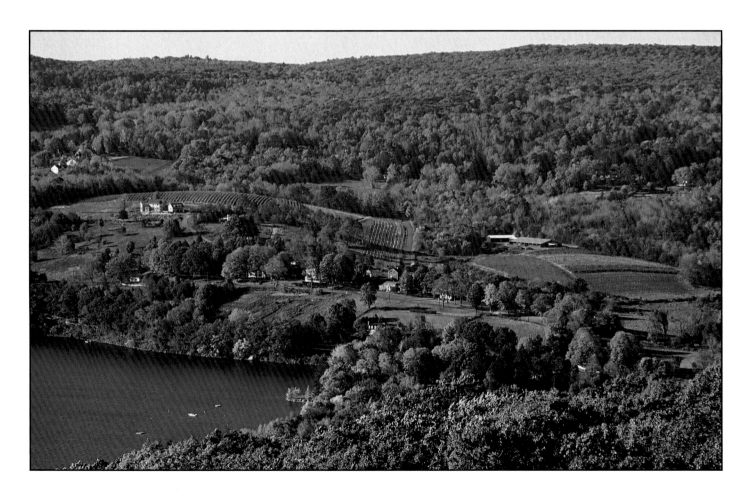

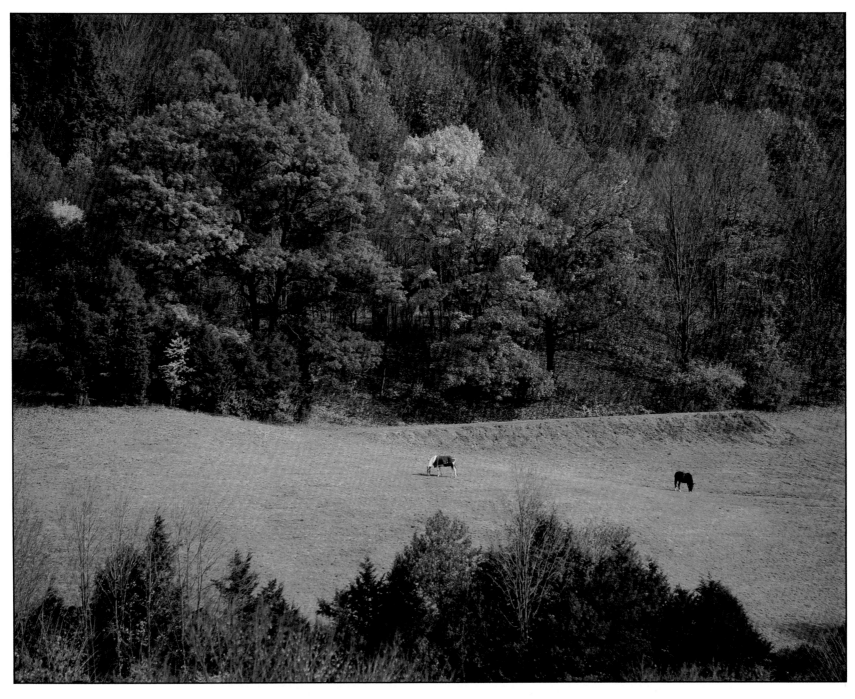

Farmland still serves as pasturage, of course, as for these horses near
Thomaston . . .

. . . and here between Limerock and Salisbury.

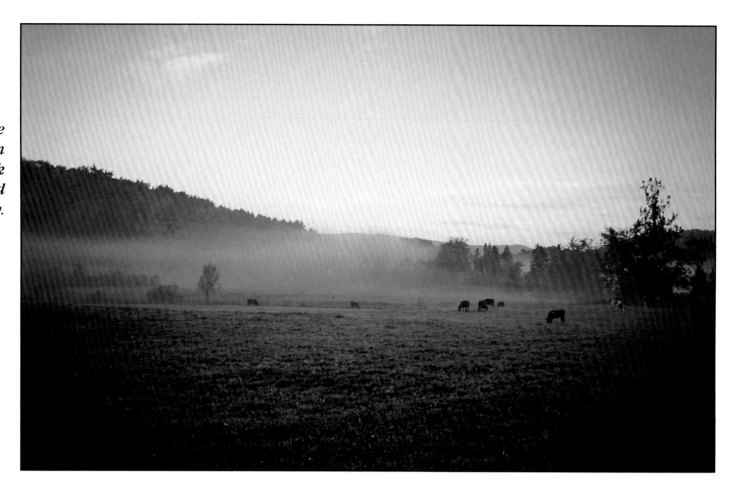

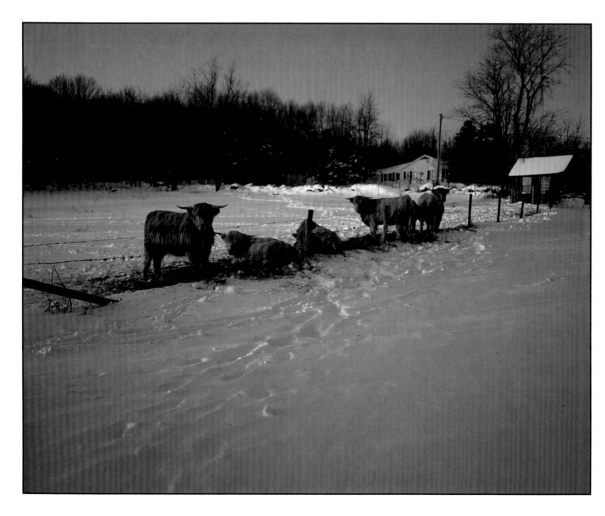

Newcomers are found among livestock, just as among home-owners. Buffalo, llamas and ostriches have all taken up residence, as have these Highland Cattle in South Kent.

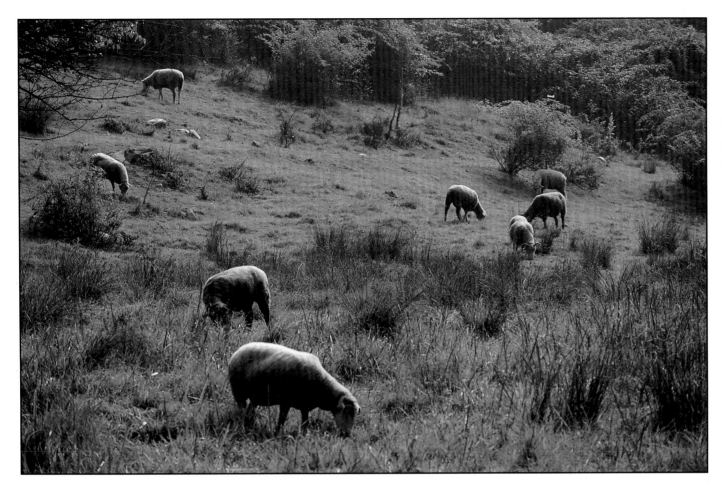

The old tried and true are around, of course.

But some local herds are more pigment than real.

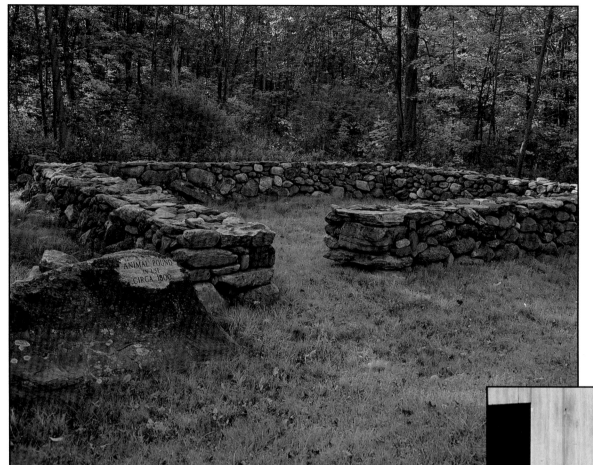

Some once needed empounding,
for unrelated indiscretions, as was
the case in North Goshen, at least. (Top.)

Life down on the farm still reflects
a myriad of moments, as does this still life,
taken along Painter Ridge in Roxbury.

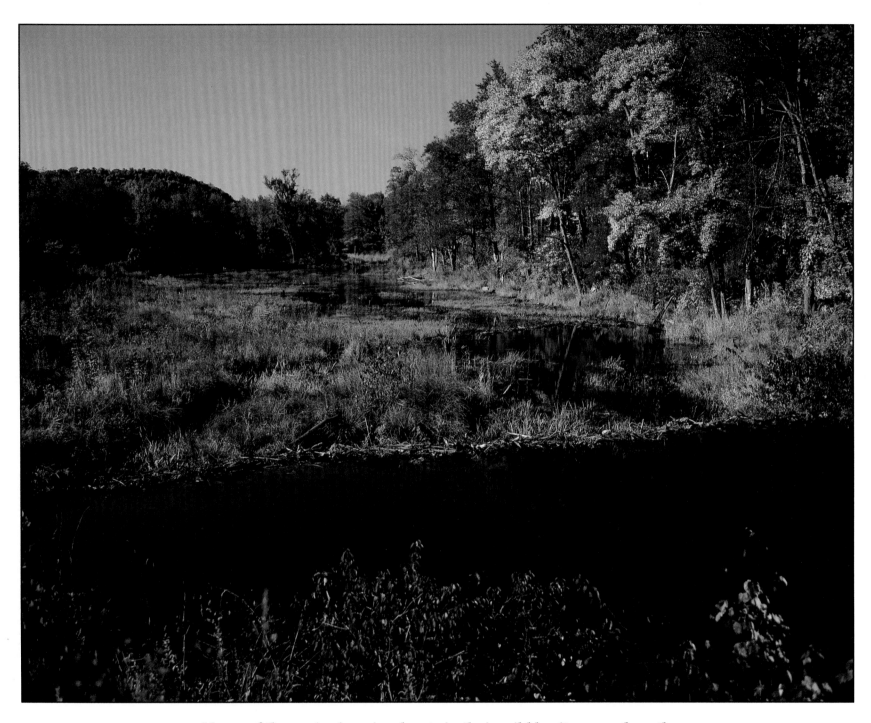

Many of the region's animals retain their wild heritage, such as the beaver, newly returned. His dams change the ecological nature of their surroundings, by design.

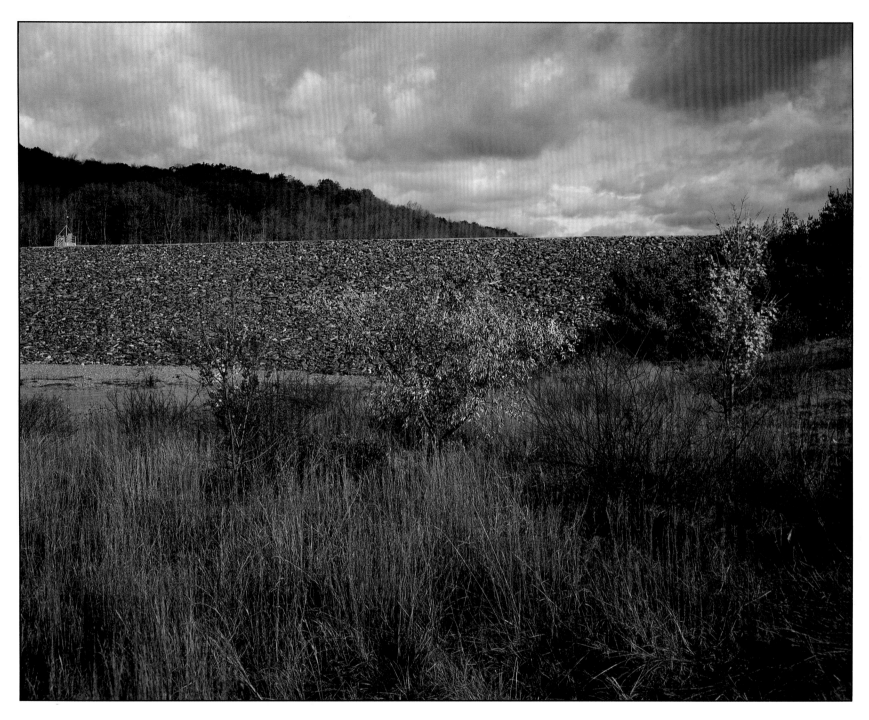

Emulating the beaver, Man has harnessed the potential dangers as well as benefits of water, as with the Hancock Brook Dam in Plymouth.

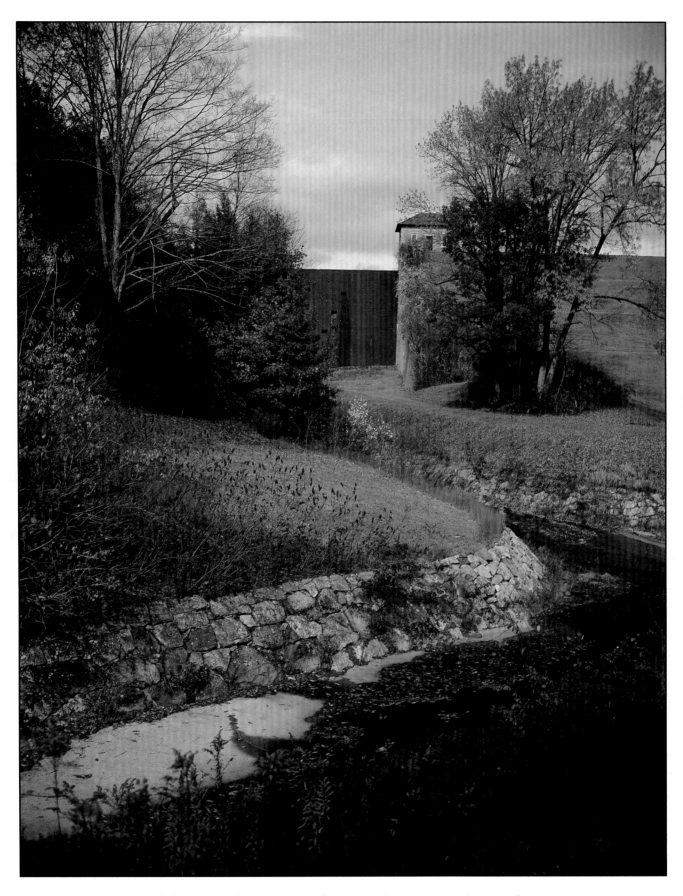

One of the more impressive dams in the county rises up between Morris and Thomaston, controlling flood waters and forming the Morris Reservoir.

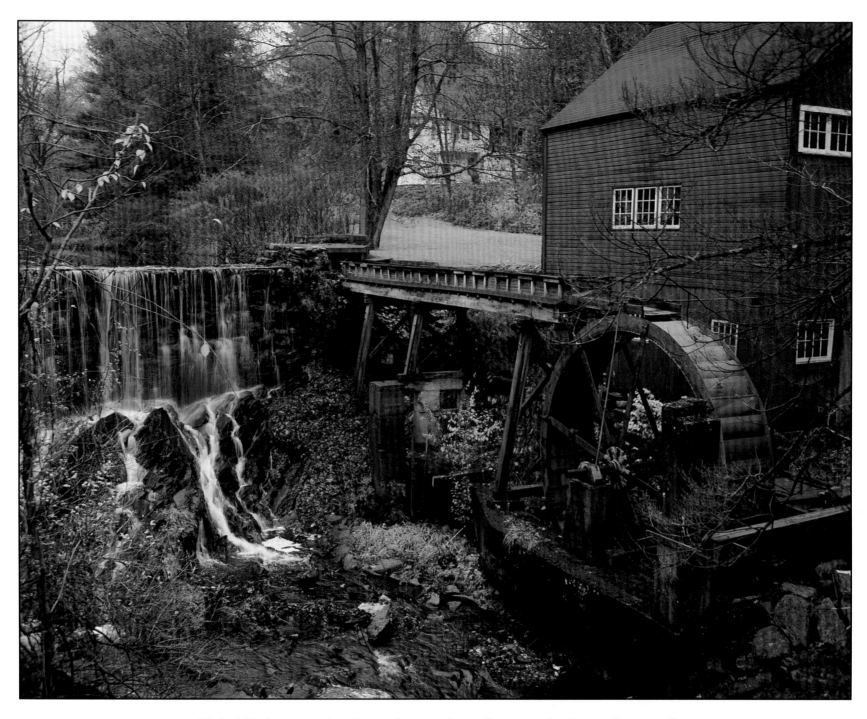

Unbridled energy is often what early settlers sought from river and stream. Sinew, as well as serenity, can be found in flowing waters. This mill is still operable in Bridgewater.

A world famous manufacturer remains hard by the Farmington River where it was founded in the 1820's. While water power is a distant memory, the site remains a buyer's mecca.

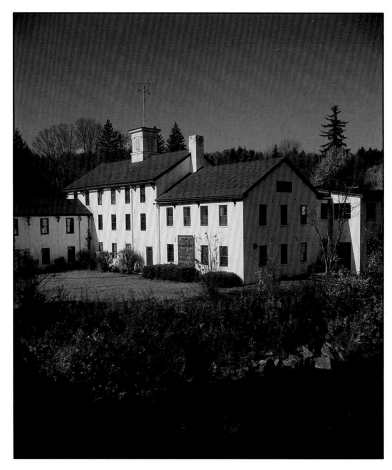

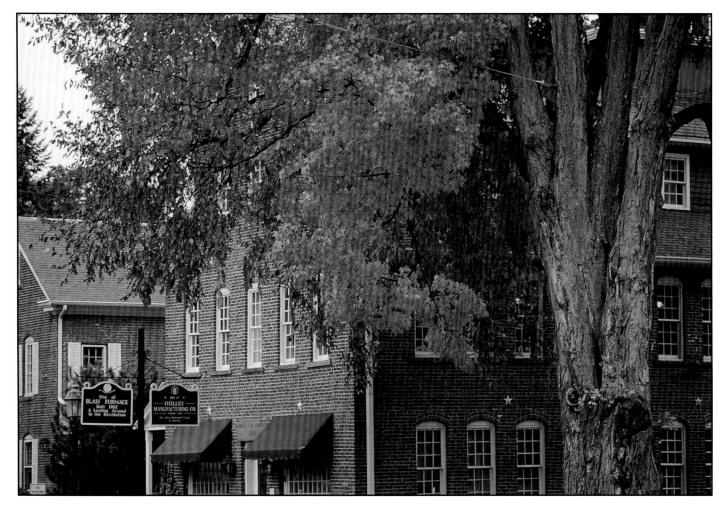

Lakeville's early manufacturing history finds eloquent testimony in Pocket Knife Square.

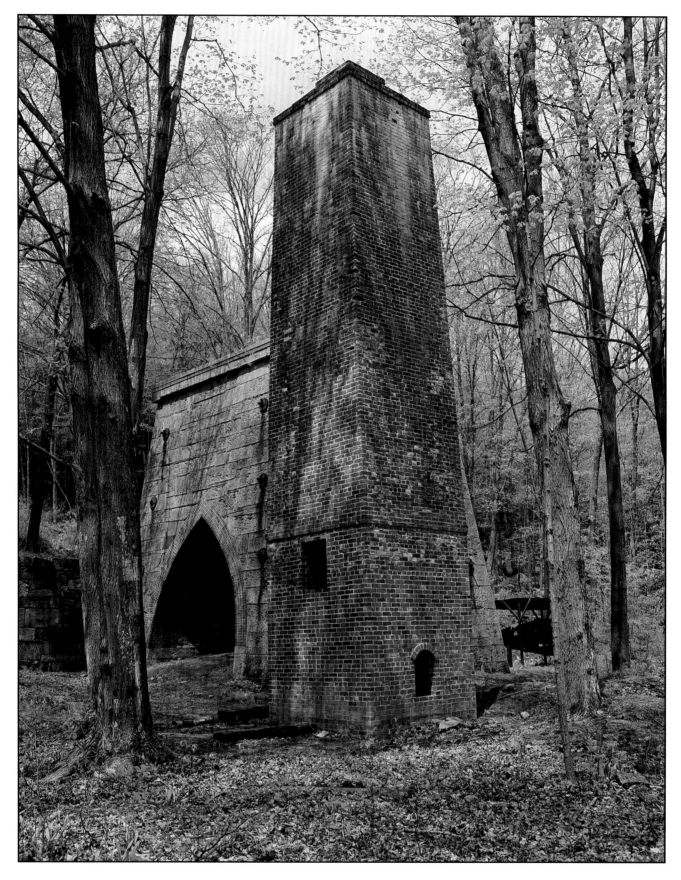

The principal cause of the region's early industrial development was the abundance of iron ore to be found. Huge tracts of land were cleared to fire the furnaces, such as this one in Roxbury, from pre-Revolutionary times through the Civil War.

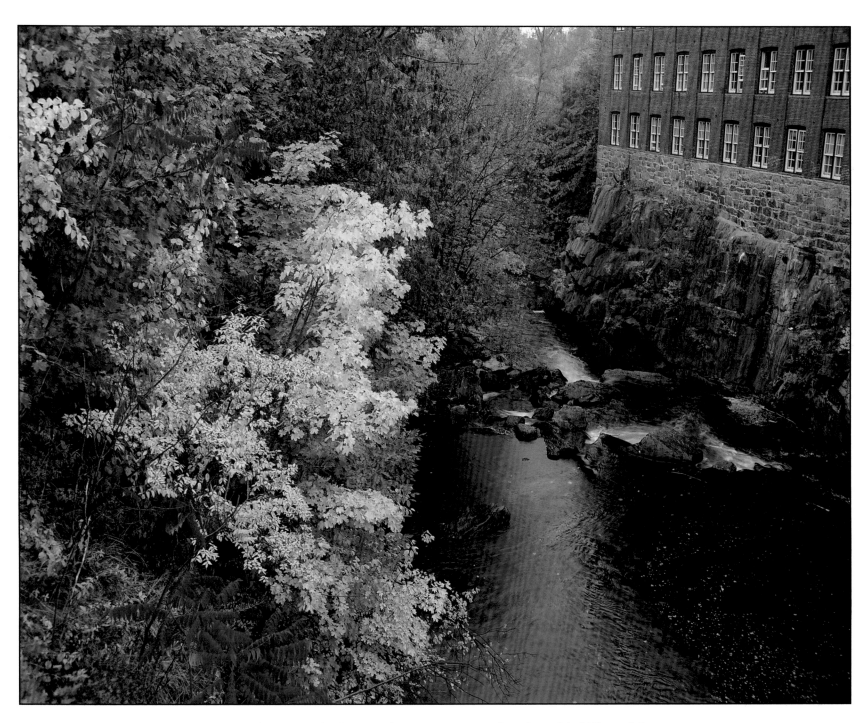

North of Winsted, the Mad River courses by the old Gilbert Manu-
facturing Company that stands on the site of a mill that dated to
1776, and a clock industry that dates from 1807.

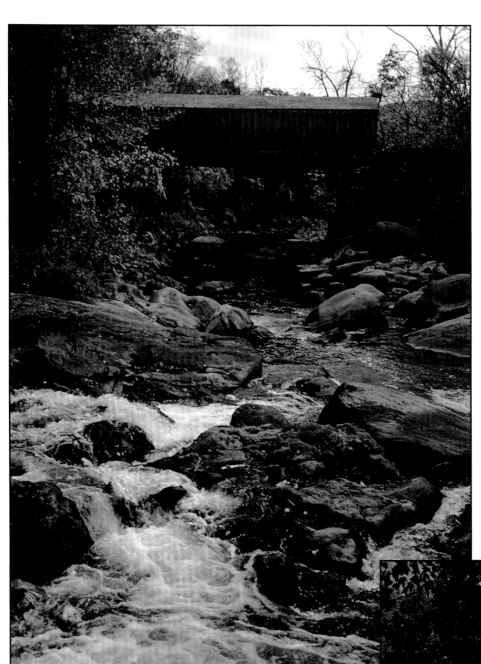

Where rivers run, and men are wont to cross, there must be bridges. The county can boast two prime examples of the covered variety, one at Bull's Bridge . . .

. . . the other at West Cornwall.

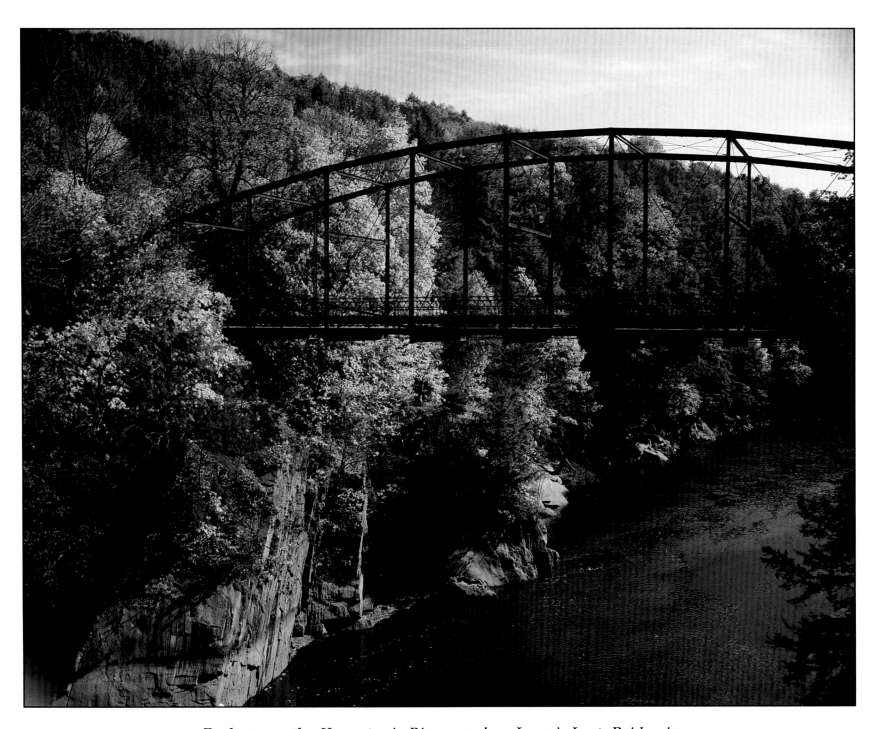

Each spans the Housatonic River, as does Lover's Leap Bridge in New Milford. This classic iron structure was built near the site where Princess Lilinonah plunged to her death, according to legend, when her European love failed to return to her. The gorge is reputed to be a tectonic scar left by a great geologic shift.

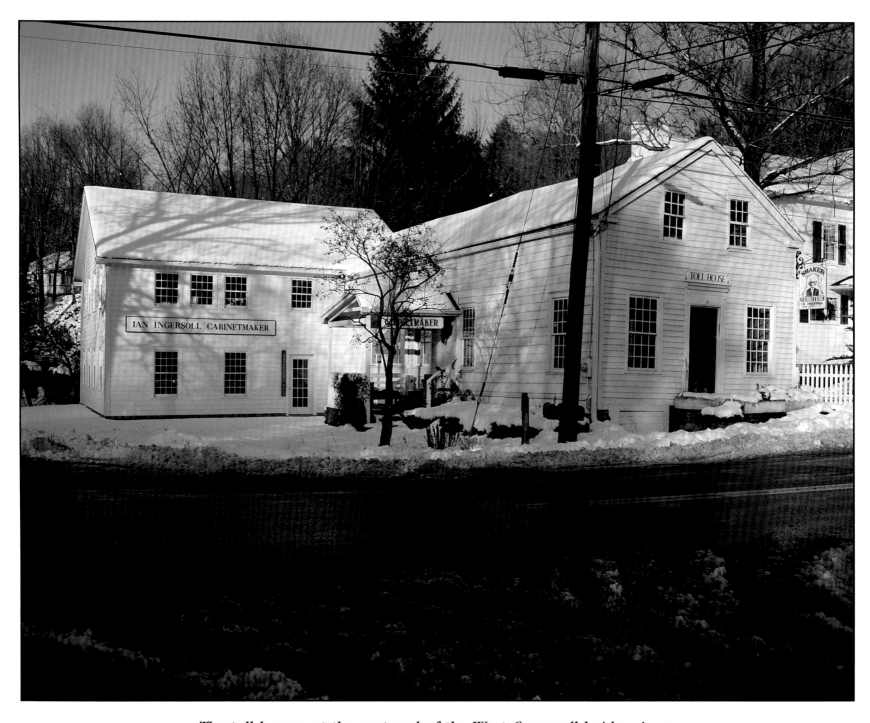

The toll house, at the east end of the West Cornwall bridge, is an evocative reminder of the many points of travel where fees of passage were regularly levied well into the 1800's.

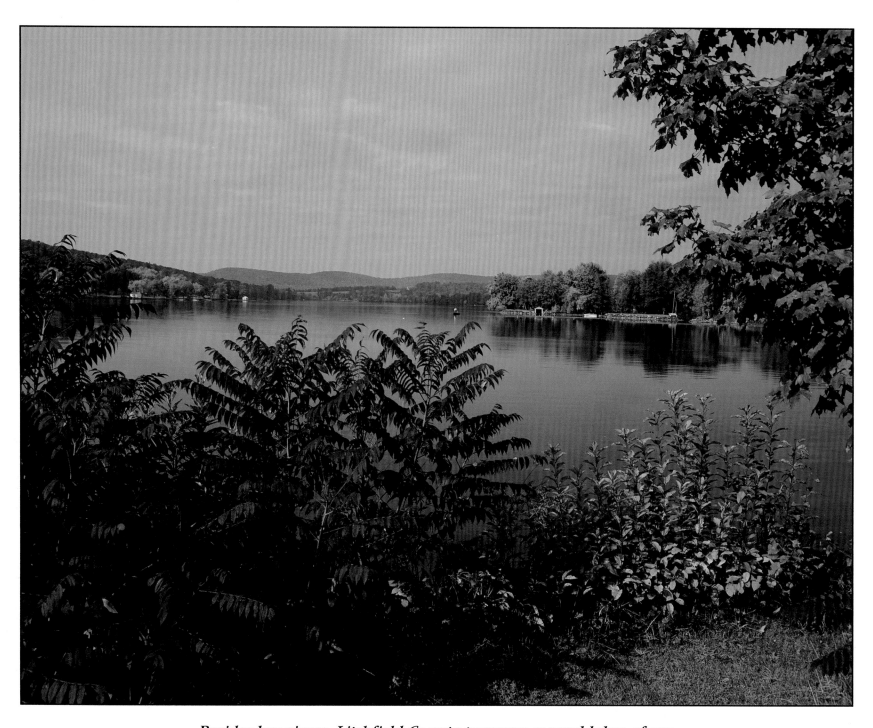

Besides her rivers, Litchfield County possesses several lakes of sur-
passing beauty. Lake Waramaug, as viewed from the New Preston
end, wins high marks from any angle.

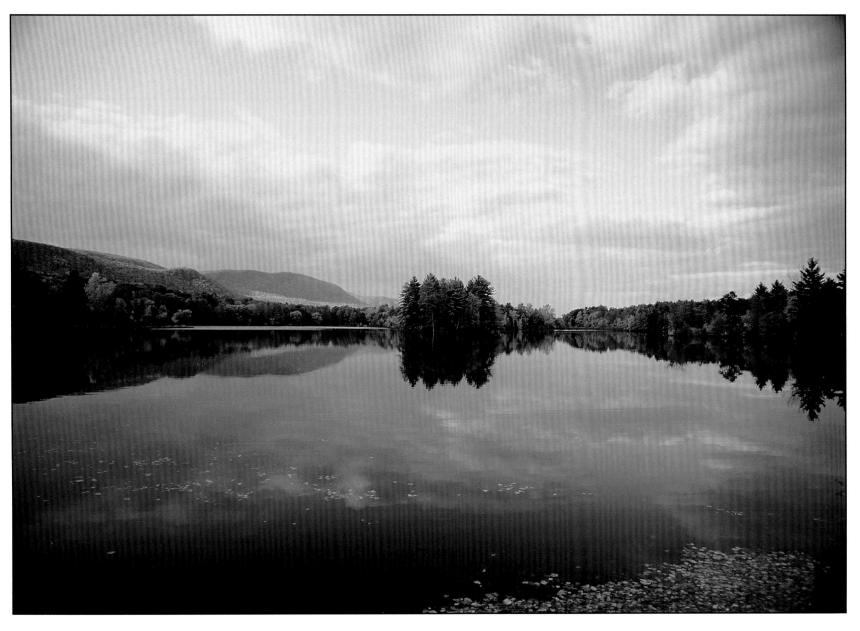

Mount Riga, the state's tallest peak, rises to the left of a placid Taconic Lake, north of Salisbury.

In the eastern portion of the county, Plymouth Lake serves a fortunate community of week-enders and year-rounders alike.

And back in the northwest section, Washinee Lake, the more western of the Twin Lakes, reflects the last light of a late autumn day.

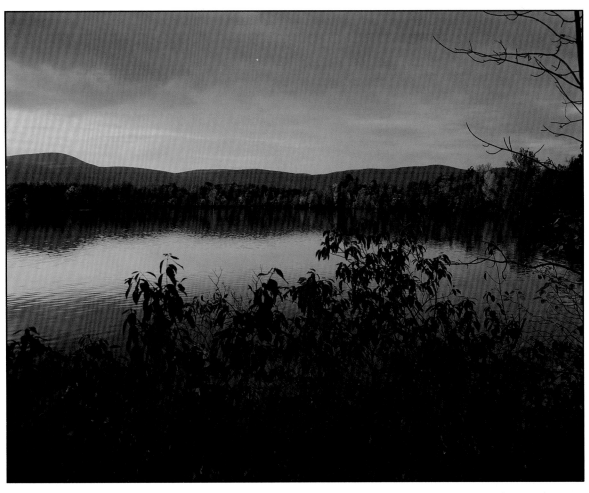

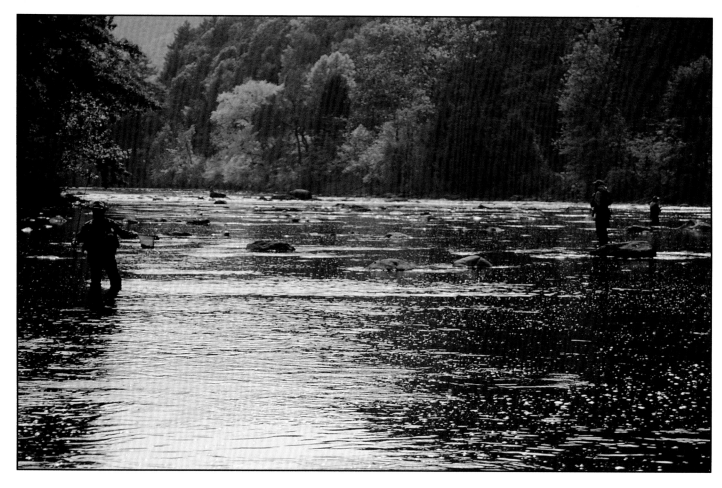

Water means life. It can also lend itself to the stuff of dreams, as for these fishermen along the Housatonic above Cornwall Bridge.

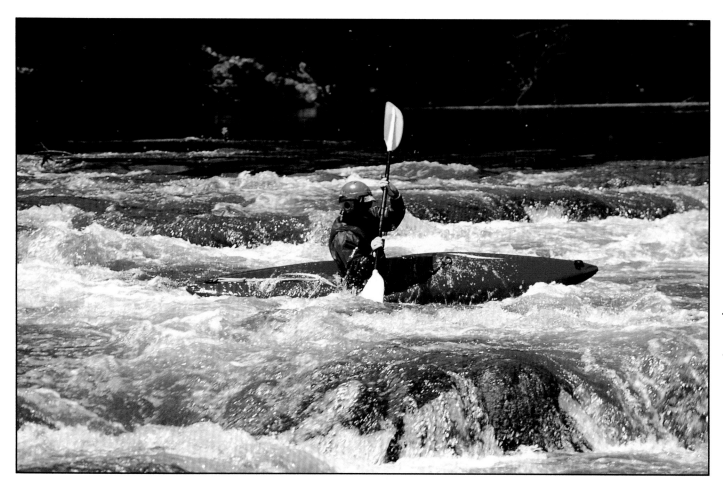

It can also mean a pulse-racing challenge, as for this kayaker at Bull's Bridge — just as it might mean peaceful passage for canoers and others elsewhere.

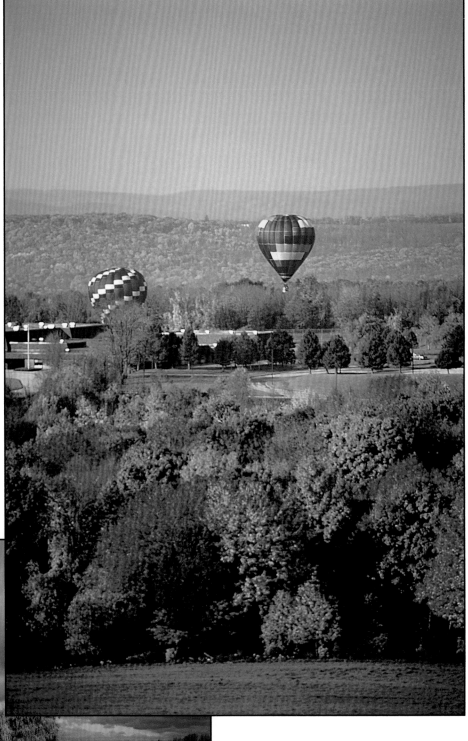

Recreation extends from the waters through the air. Ballooning is an ideal way for the adventurous to view the many layers of the land from above.

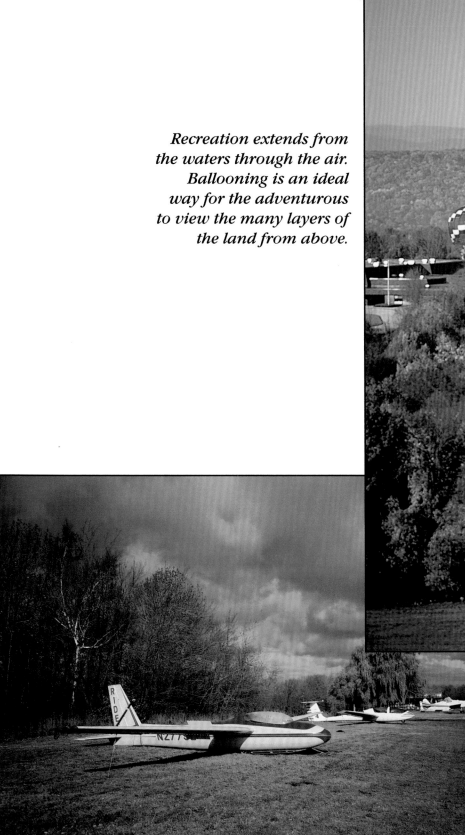

Air travel of another sort awaits the growing number of those who swoop and soar, drift and glide, lifting off from such fields of dreams as this one near Plymouth.

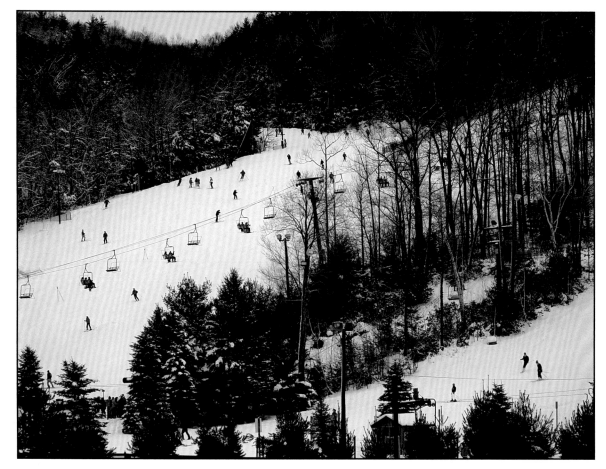

For those who choose to swoop and dive with their feet closer to the ground, there are ski slopes for all ages in the county, such as this one near New Hartford.

For acceleration and hairpin turns, the graceful lines of a top race track draw crowds to the county's one and only Limerock.

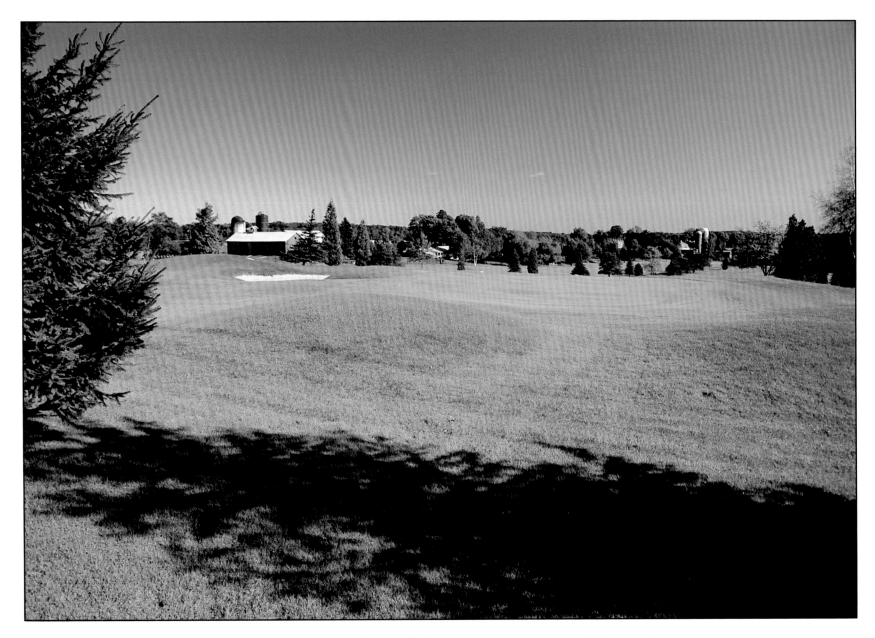

Tennis, horseback riding, sailing, even croquet and horse shoes have their avid adherents in these parts. None can be done justice here. The Royal and Ancient pursuit of the Nameless, however, needs mentioning. There are more than ten courses county-wide, each with its own charm. Torrington's private course shares the landscape benignly with neighbouring farms in Goshen.

Lake Waramaug serves as a perfect backdrop to this par three in New Preston.

No course is more readily identifiable than this one on the campus of Hotchkiss School, Lakeville's own contributer to educational excellence.

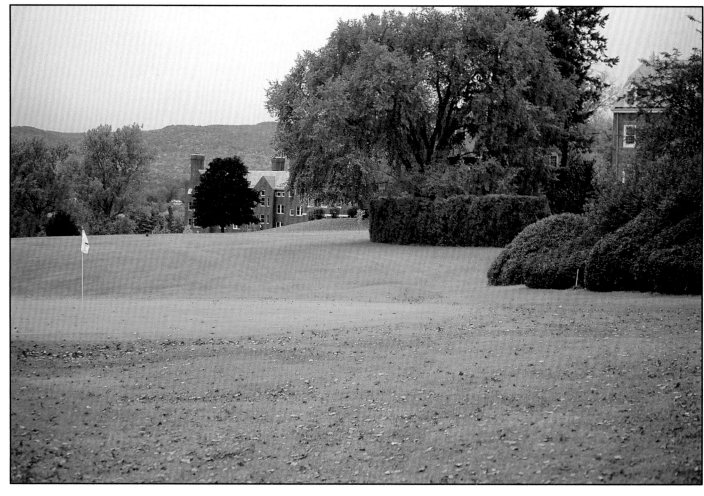

Schooling has played a significant role throughout the history of the county. Early schoolhouses remain in evidence, if not in use. North Cornwall employed a two-storied version well into this century.

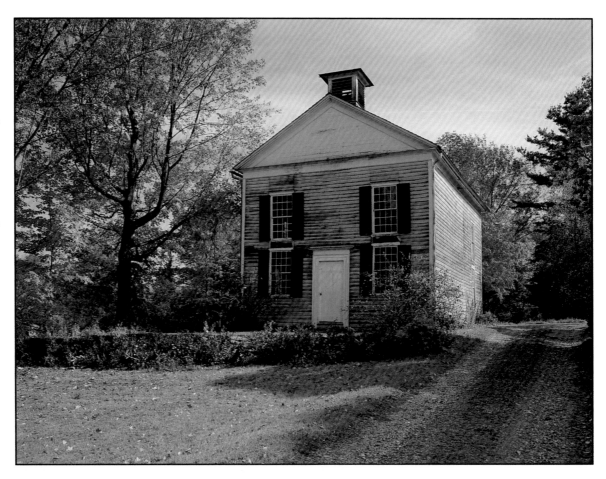

The Brick School can be found along its own road in Warren.

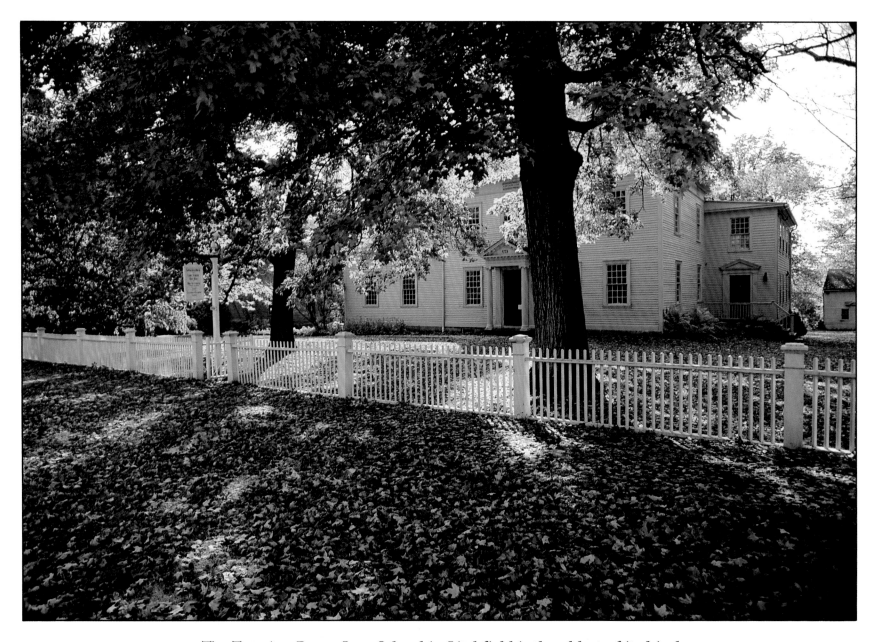

The Tapping Reeve Law School in Litchfield is the oldest of its kind in America and is carefully preserved by the local historical society that maintains the property as a museum.

The county hosts a proud array of other schools that follow early, high-minded precepts. As well as Hotchkiss, there is The Taft School in Watertown that can claim a leading role in education for generations.

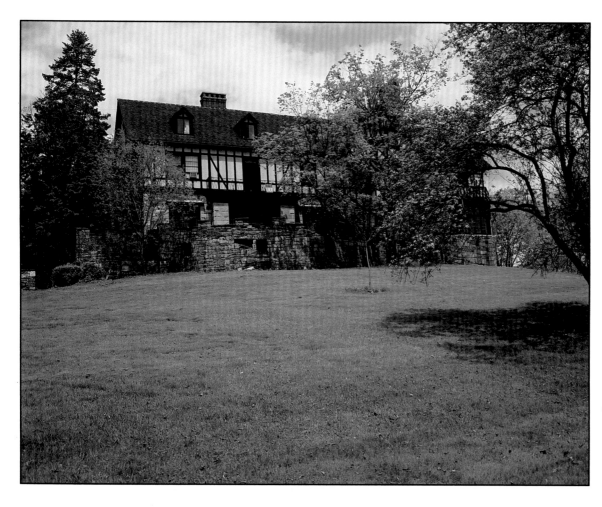

The stolid weight of Gunnery's Bourne Hall bears proof of the practice of bringing new life to old structures. This former estate house has been brought into the learning circle in Washington.

Besides old forms, new ones spring to life in academe as elsewhere. The Kent School hockey rink fits comfortably beneath the rise of Skiff Mountain.

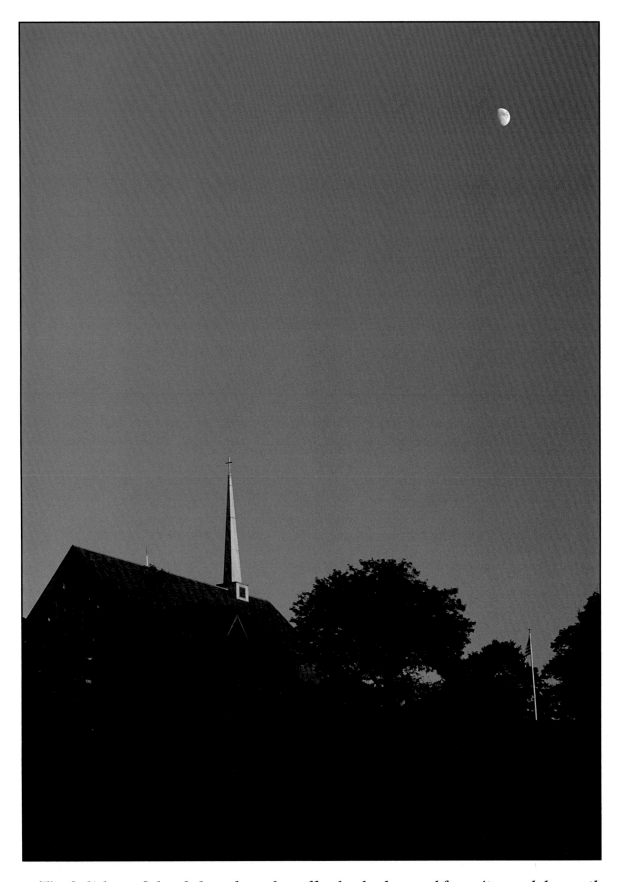

The Salisbury School chapel reaches effortlessly skyward from its perch beneath the moon.

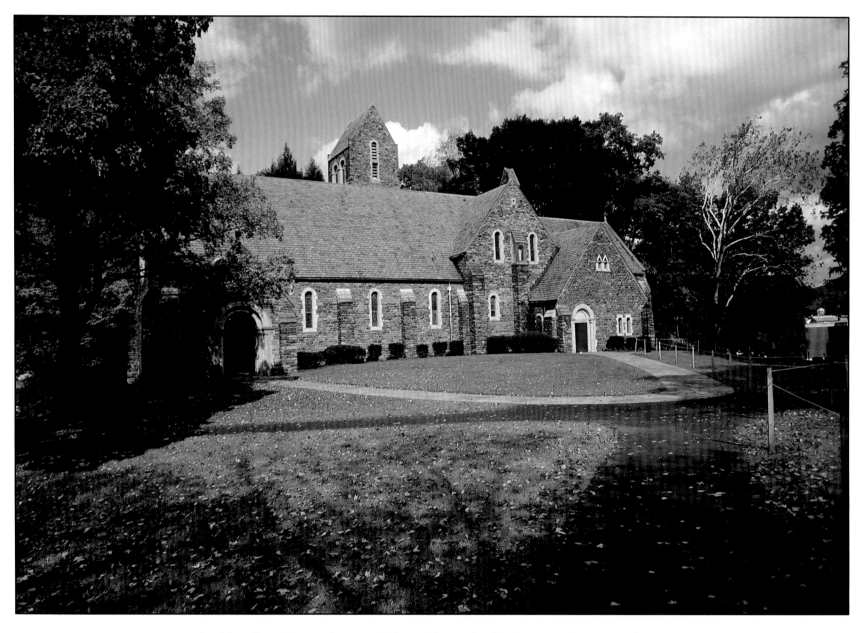

*And back at Kent, the traditional is embodied in the famous chapel
at the center of its recently enlarged campus.*

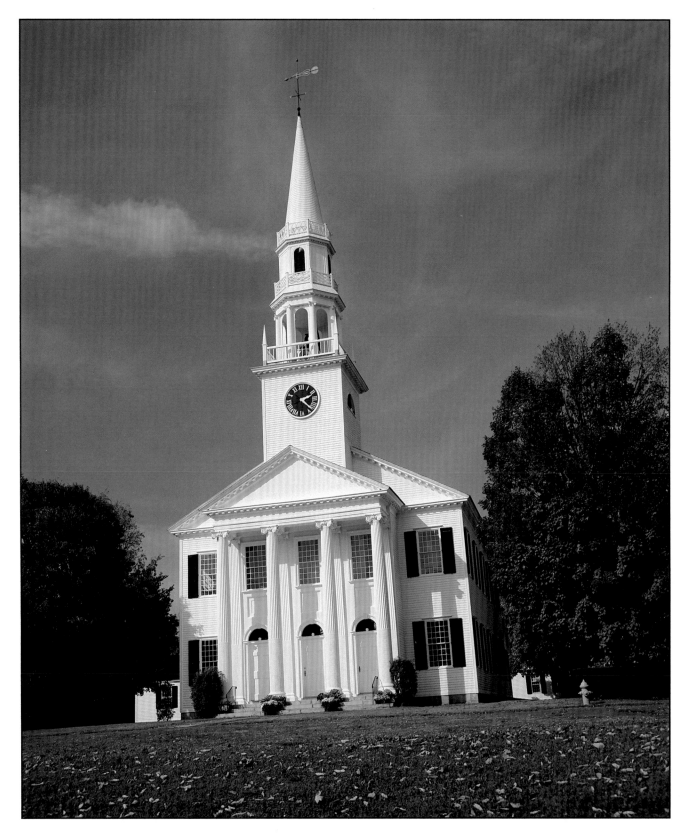

The role of religion in any community, whether academic or civic, is as old as the earliest settlements. The centerpiece of each town, both architecturally and socially, was the clapboard building raised by the Presbyterians, later known as Congregationalists. Litchfield's – typically not the first as most early churches were destroyed by fire or replaced by grander designs – presides over the county seat with serene certainty.

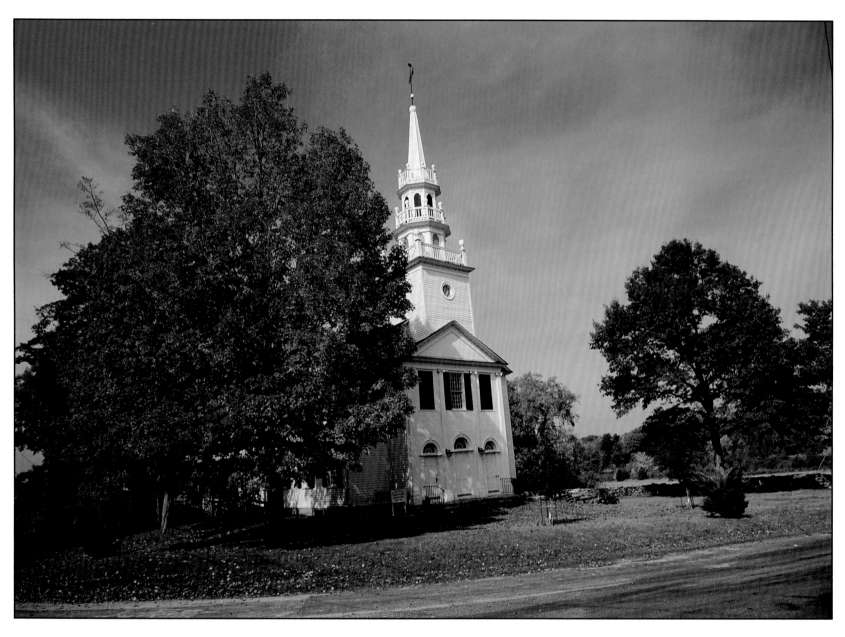

North Cornwall's setting is supremely secluded, retaining a strong sense of a small community.

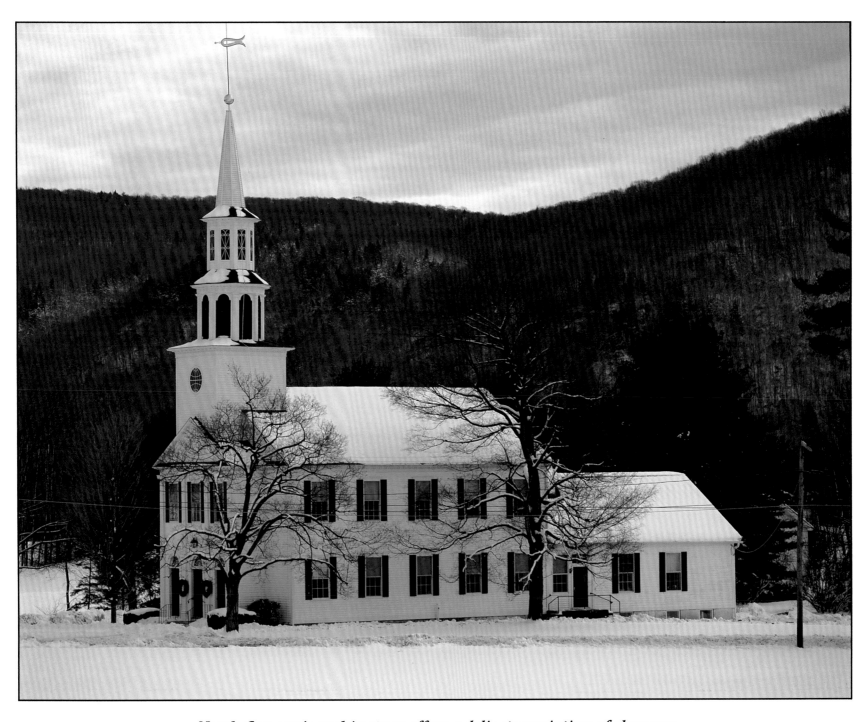

North Canaan's architecture offers a delicate variation of elegance and charm.

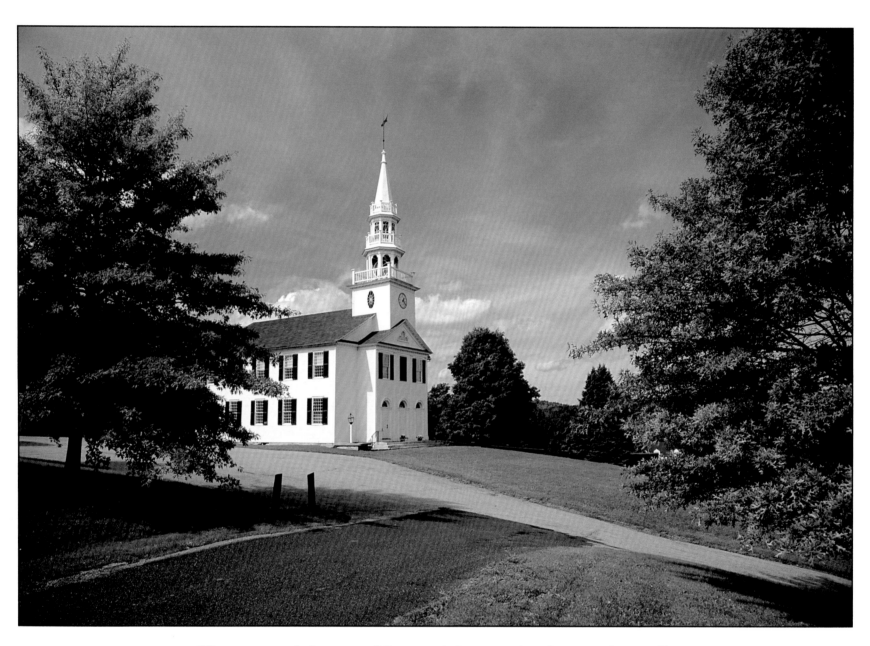

*Warren can claim one of the area's true masterpieces and proudly
displays the "meeting house" high above the tiny town.*

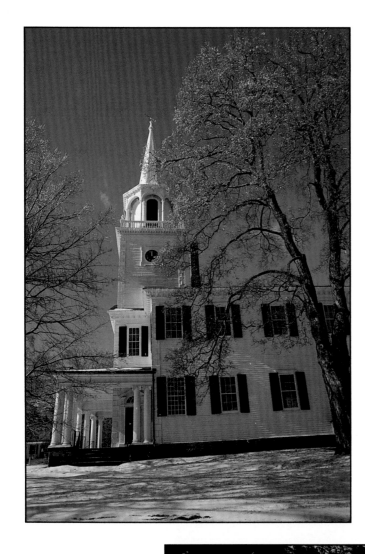

The church on the Green in Washington adds luster to an icy scene.

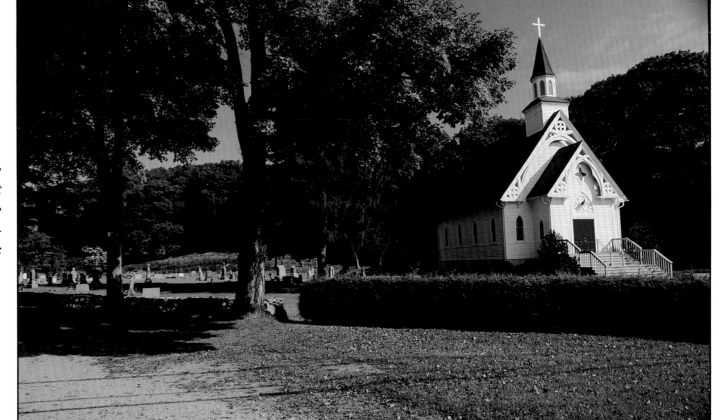

While the church at Cornwall Bridge stands protectively near its churchyard.

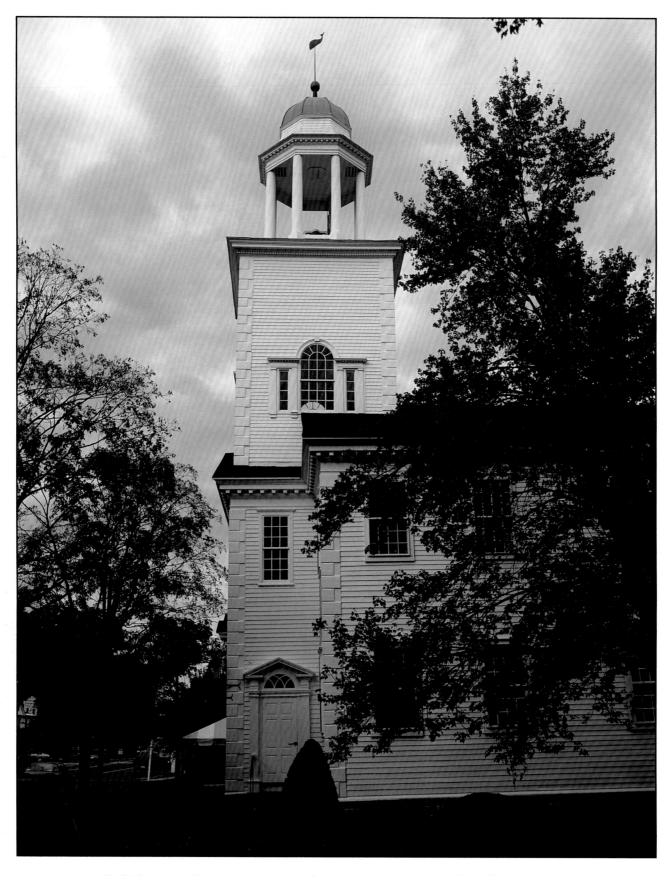

Salisbury's place of worship, featuring a tower rather than a spire,
draws attention to the details of its design.

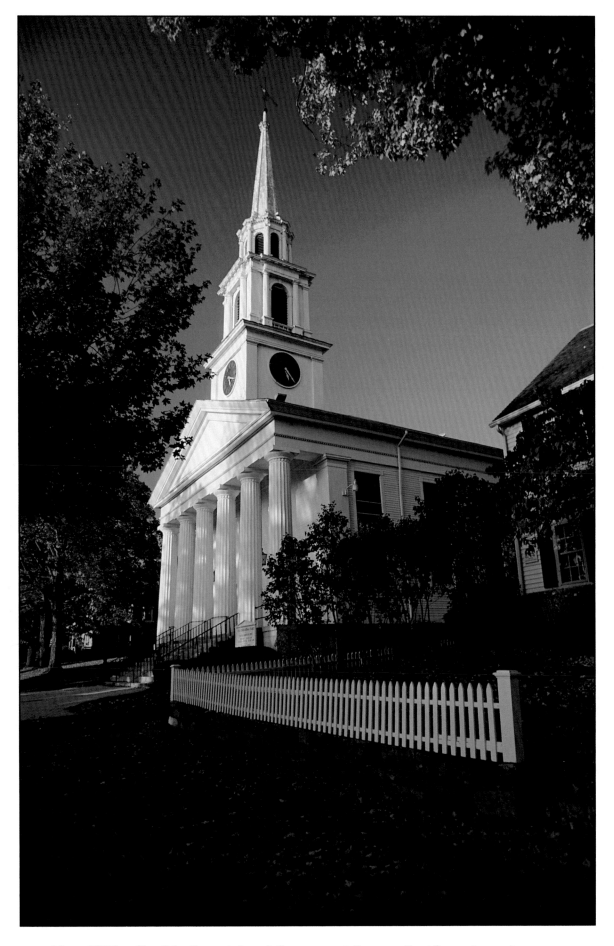

New Milford's elderly patriarch keeps watch over that busy town's green.

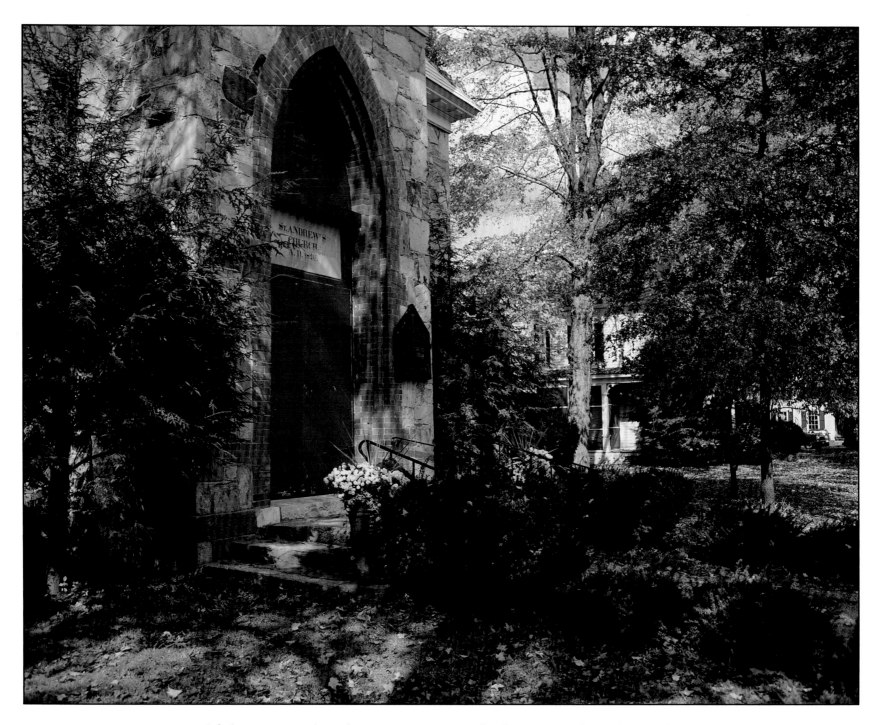

Of the many other denominations and religions in the county, the Episcopal sect, tracing its American origins to the Glebe House in Woodbury, is among the oldest established presences. Its church in Kent resonates in the autumn light.

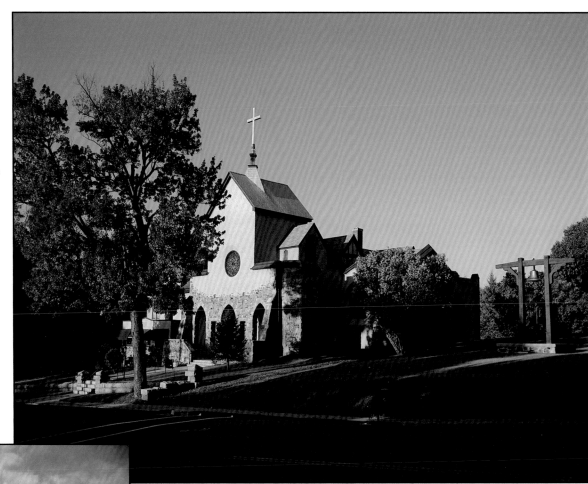

The striking design of Norfolk's Catholic church catches the eye of the traveller entering town from the west.

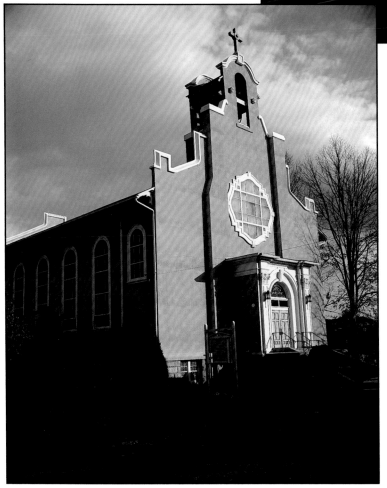

To the southeast, in Torrington, another distinctive design graces a church of the same faith.

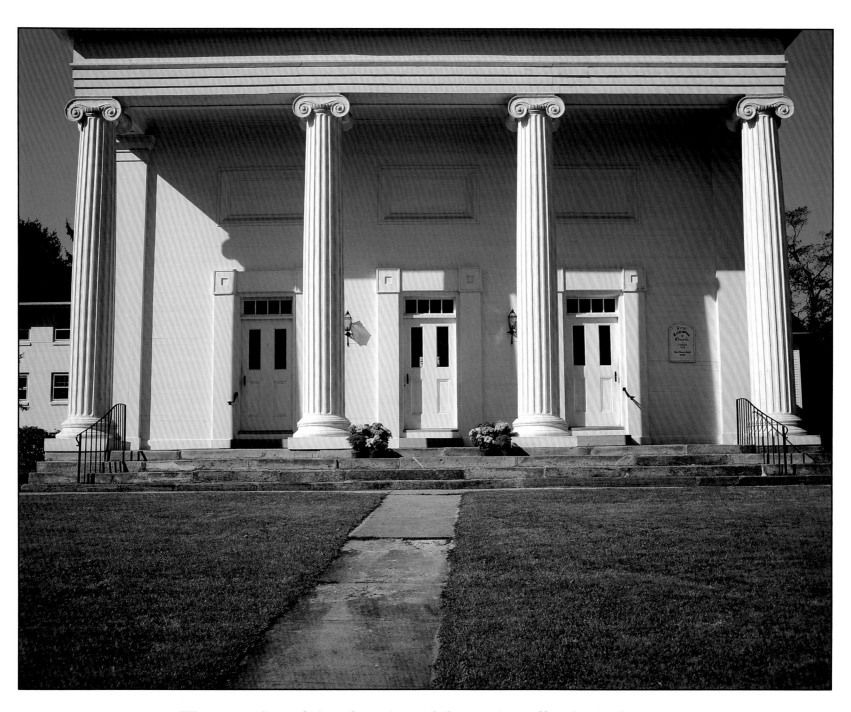

*Watertown's traditional version, while massive, offers Ionic elegance
and a soaring presence.*

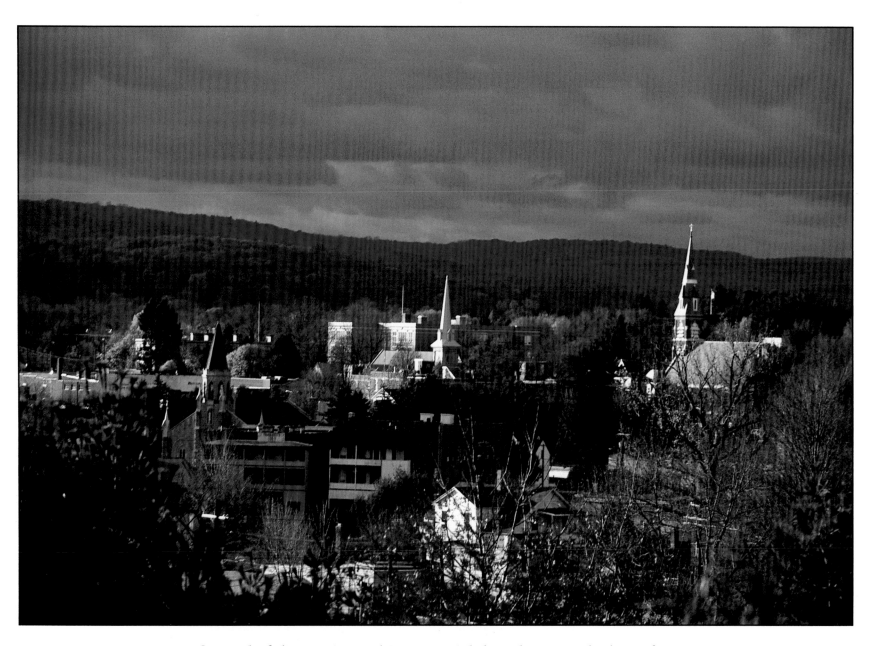

Several of these spires achieve a weightless charm in the late after-noon sun streaking across Torrington.

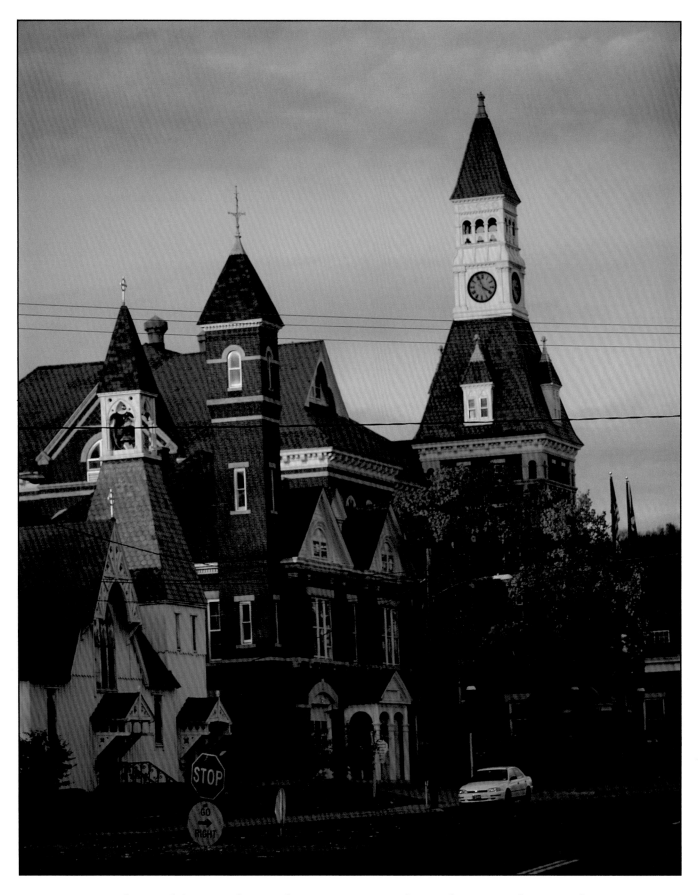

An architectural symphony resonates from the central part of Thomaston, as famous for its clock factory as it should be for this impressive display.

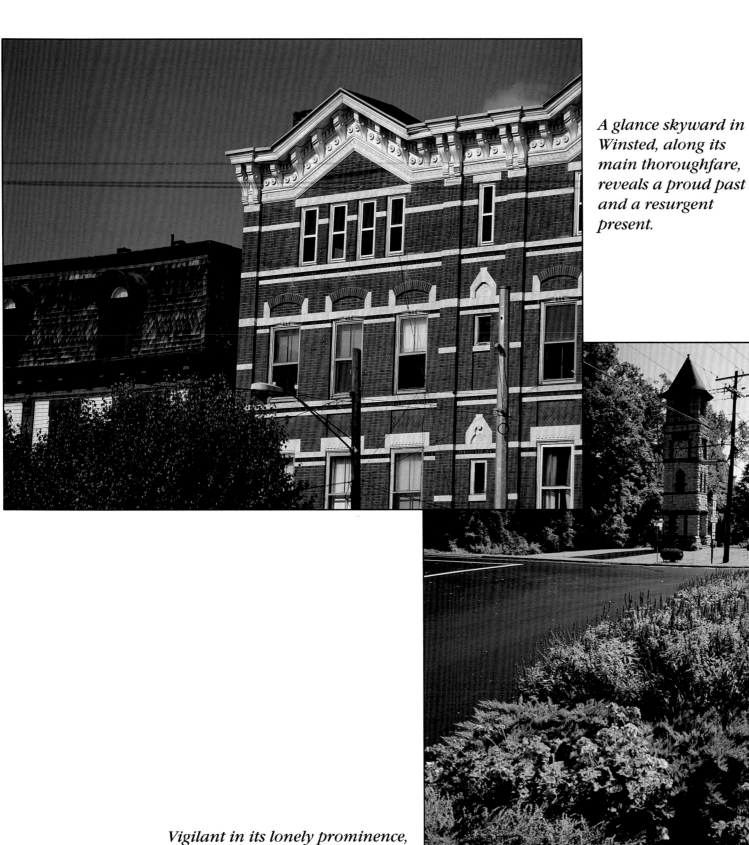

A glance skyward in Winsted, along its main thoroughfare, reveals a proud past and a resurgent present.

Vigilant in its lonely prominence, the landmark tower in Sharon bears witness to the Victorian predeliction for mass, in constructs of stone.

*Also prominent, though seldom lonely, is the County Court House
in Litchfield, an appropriate articulation of its weighty role.*

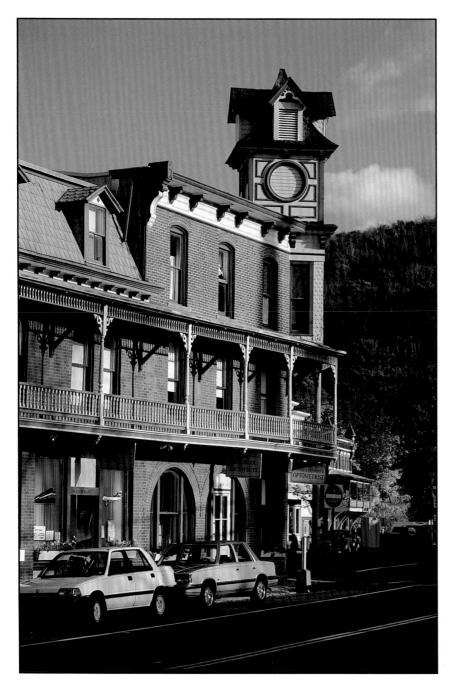

The Victorian penchant for embellishment with wood finds expression throughout the region, as here in New Hartford.

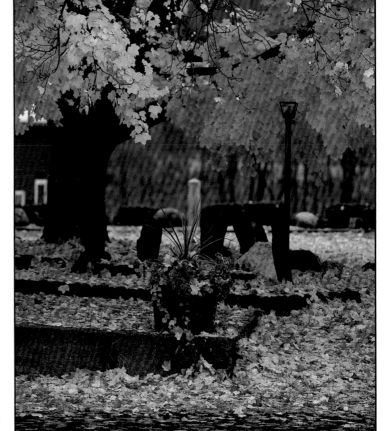

As though ecumenism were on its mind, New Hartford also offers this zen-like assemblage for the autumnal passer-by.

Standing as an architectural statement all its own is the library in Norfolk, here preparing to shrug off a wintry mantle.

The old fire house in New Milford continues to hold sway, albeit cramped, along Church Street in its contemporary incarnation.

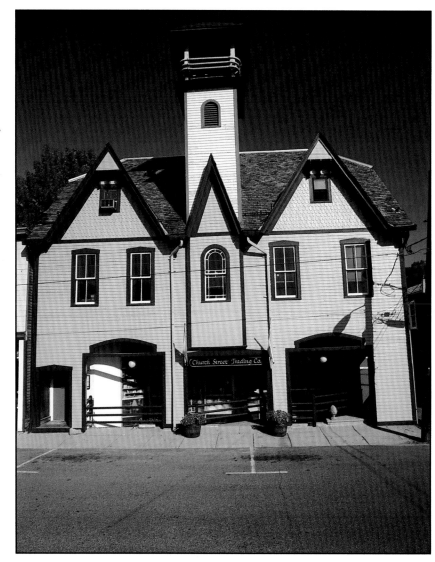

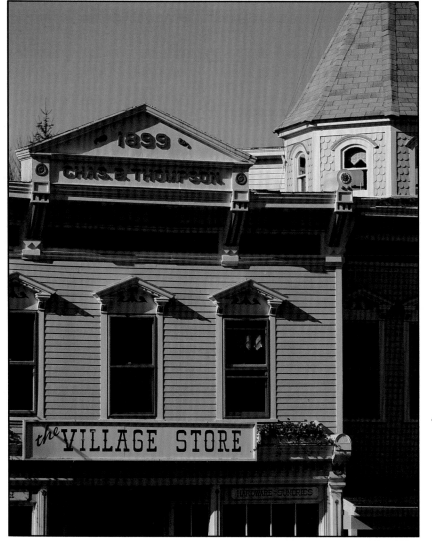

Bridgewater still bustled when this high spirited style was adopted, just a hundred years ago. The site of America's first mail order house, among many other large enterprises, shows little sign of its commercial history.

Bustle is more seasonal now, where industry has given way to stores and shops that lure visitors and locals alike in for a moment's break in their rounds. In Salisbury, a pause seems irresistible.

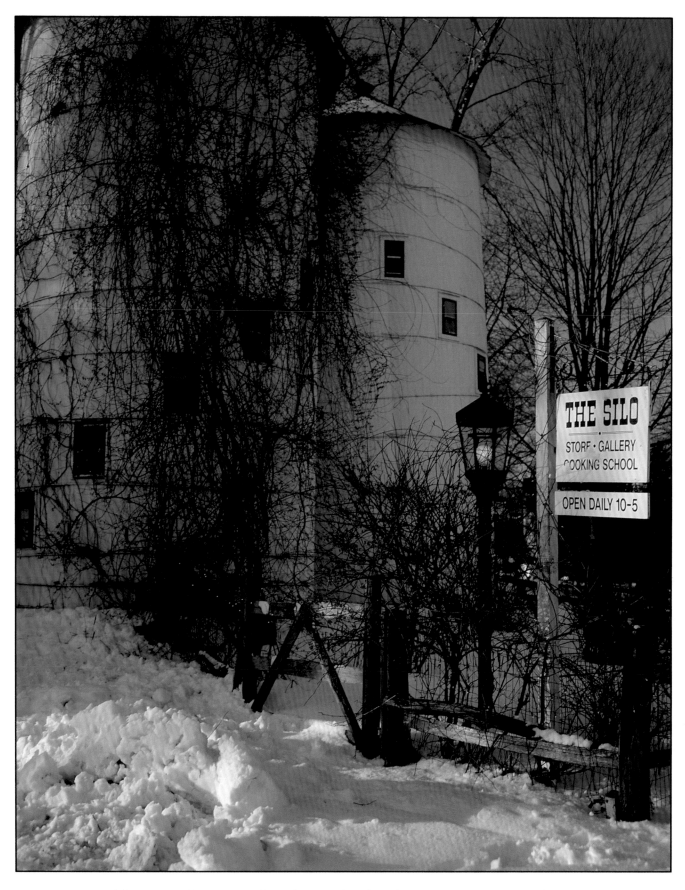

There are few more familiar sights for shoppers, or those inclined to the culinary, than this silo in Northville that gives new meaning to the expression "farm bred."

Cobble Court, in Litchfield, where stables once were kept, maintains its charm and its attraction for shoppers.

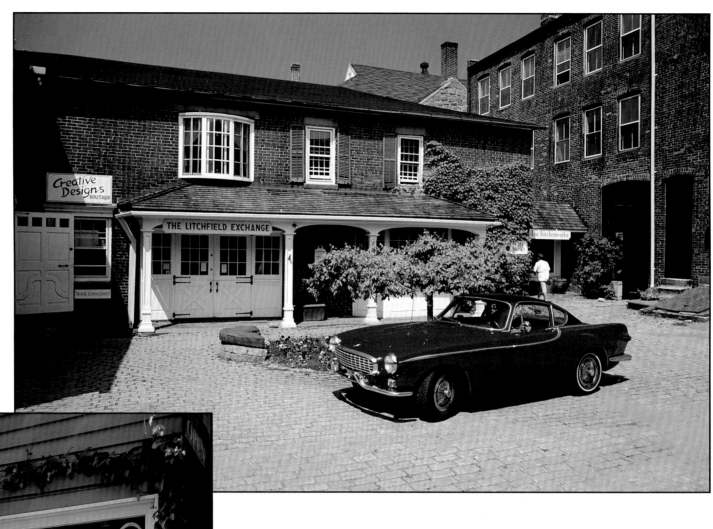

Few towns have accommodated themselves to the late twentieth century more completely than New Preston. Antiques abound where once there was only hardware, and all is thriving, as witnessed by this sumptuous display.

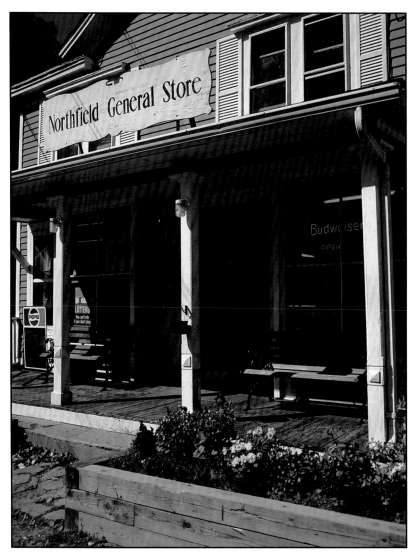

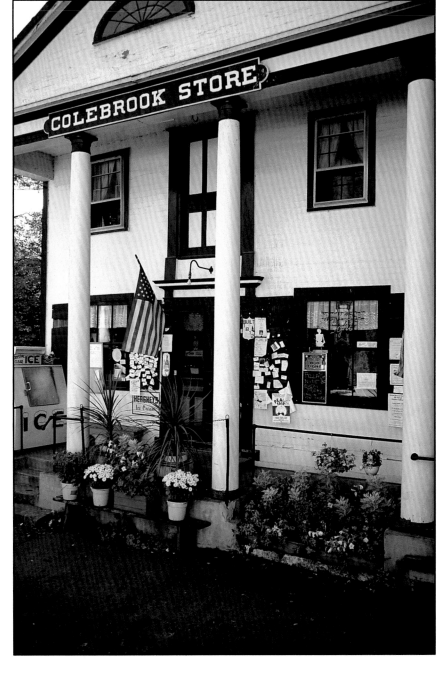

Even as some change, others do not. The old country store reflects an aspect of the area that generates delight of its own. This pair, in Northfield (top) and Colebrook, speak volumes for the way things were, and sometimes remain.

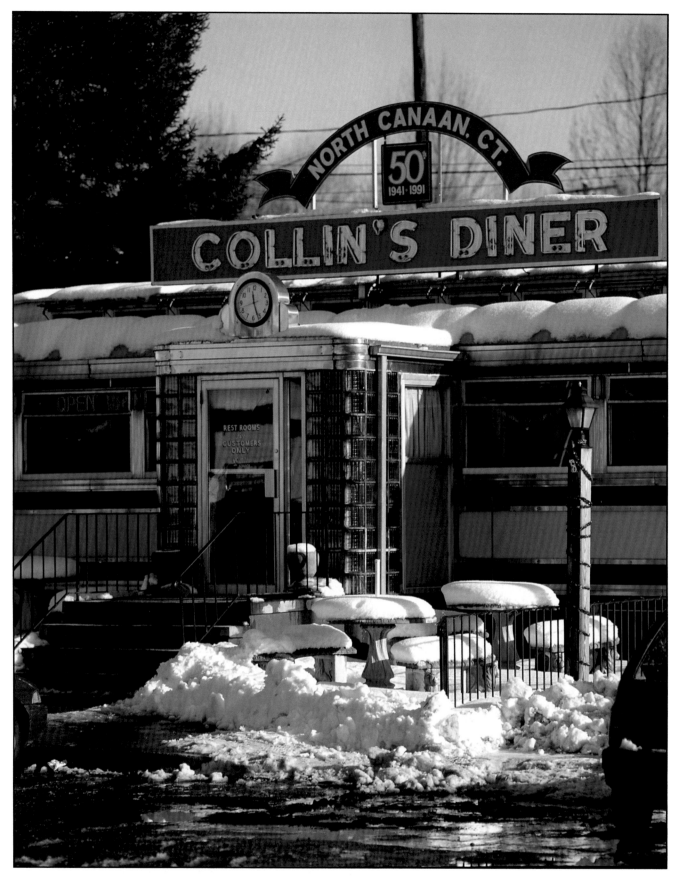

For more than fifty years, the irrepressible presence of Collins Diner has added its special flavor to the Canaan community as one of an all but vanished breed.

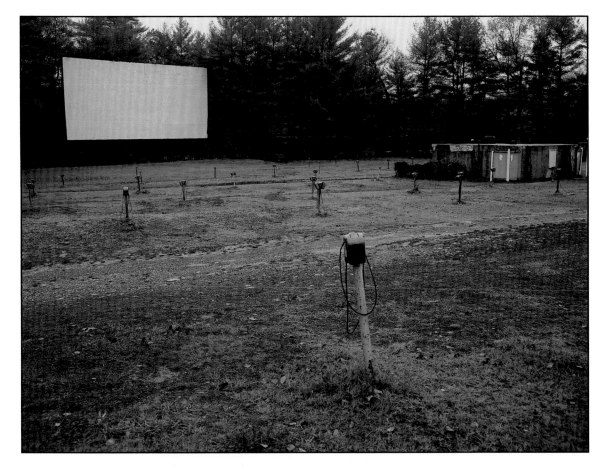

But for last-of-its-kind honors, this drive-in movie in Pleasant Valley, near Barkhamstead, plays a nostalgic role of its own.

Also unique in the county, of course, is this windmill artfully set down southeast of Litchfield.

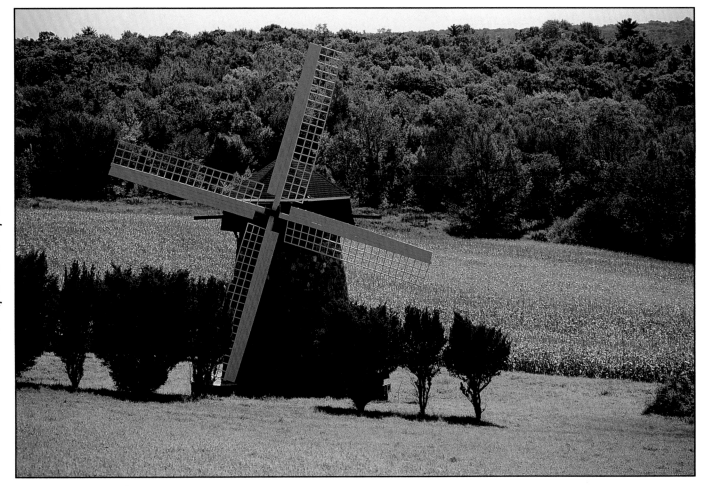

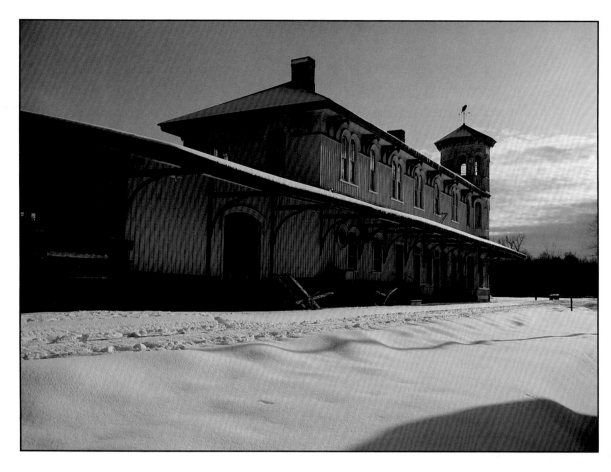

So recently commonplace, but already rare, is the sight of rolling stock, much less a working railroad station. These scenes are courtesy of Canaan's faithful enthusiasts.

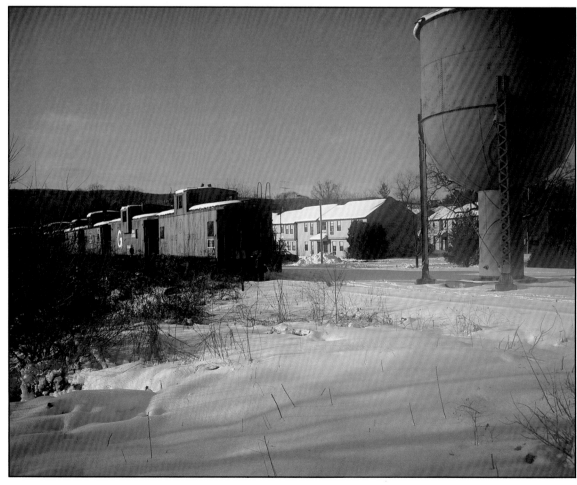

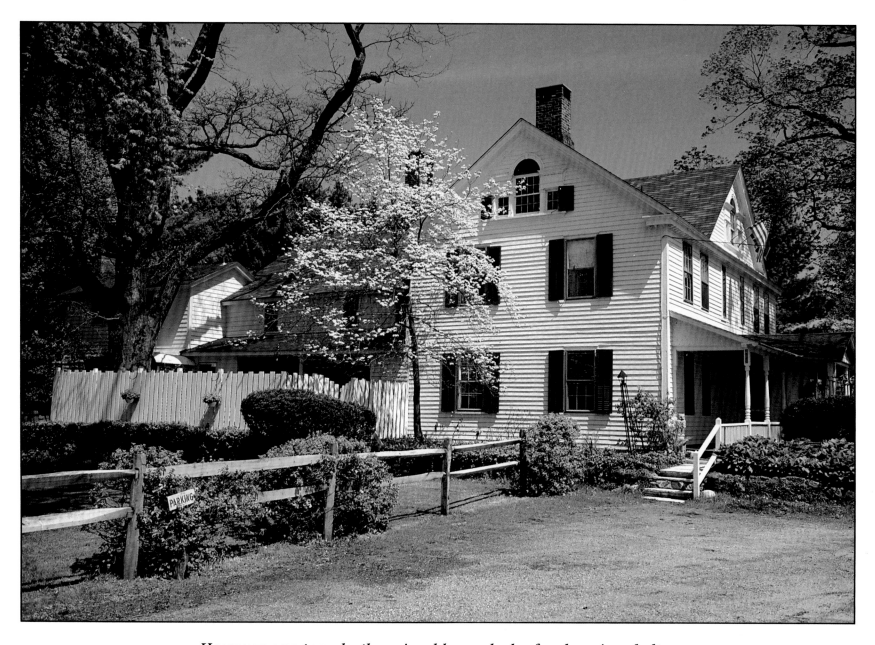

However one travels, there is seldom a lack of welcoming shelter. Early on, it was the occasional tavern and inn, strategically located at stagecoach stops, or the private home, bound by custom to give room and board upon request. (Thus the bundling board.) Today, while their numbers are diminished, area inns offer a wide variety of comfort and cuisine. This example, north of Salisbury, offers rural, old fashioned hospitality.

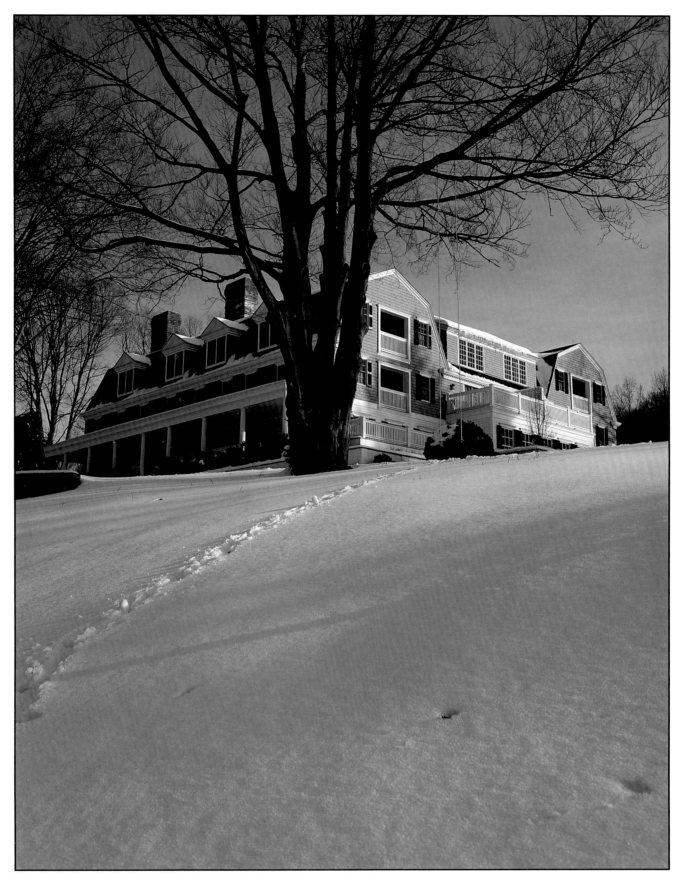

*Once a school in Washington, this recently renovated and
expanded inn has been appointed to please the most discerning.*

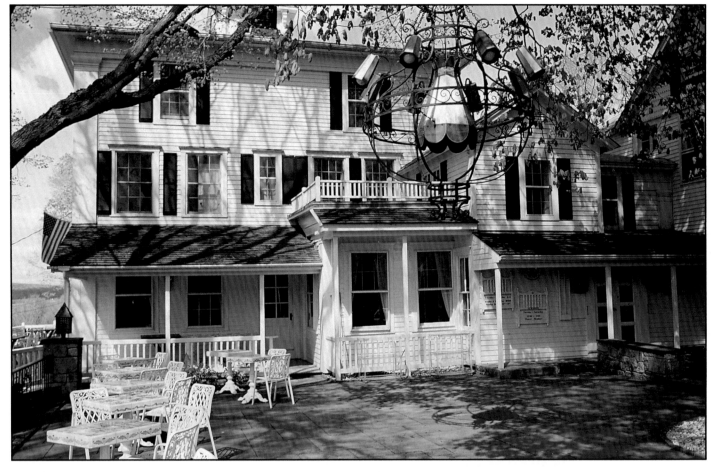

There is always the chance for a room with a view, along with fine dining, here by Lake Waramaug.

Salisbury's famous stop-over offers a choice of several atmospheres from dark, historic tavern to this light-filled modern touch.

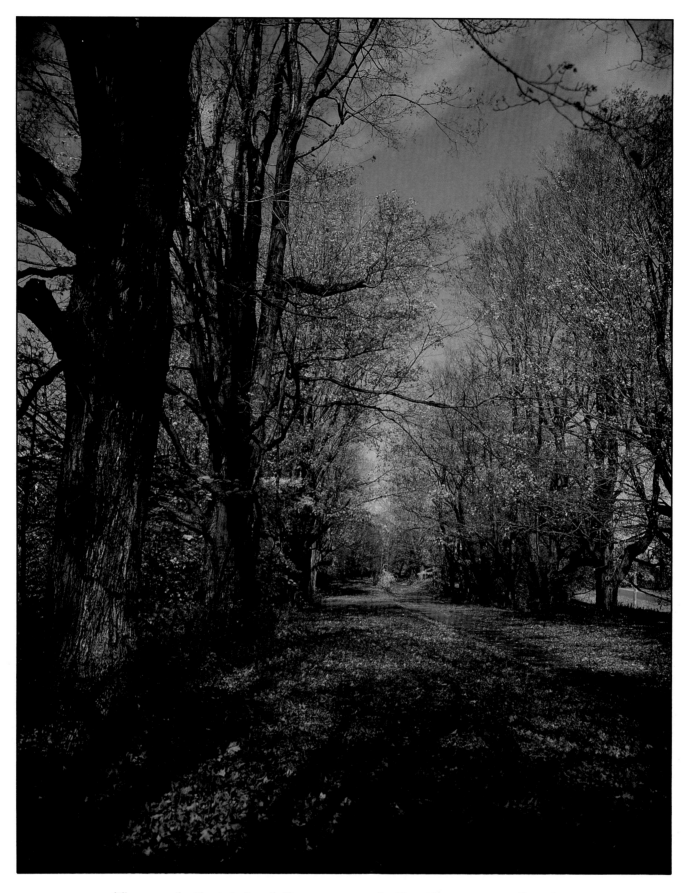

The roads that joined these many destinations were often too narrow for modern traffic. One can still discern them, guarded by towering sugar maples and long-running walls, such as here near Morris.

Many of the first roads were surveyor lanes, demarking property lines on a large scale. These often remain, at least in part, as back roads. The main ones, however, still dusty tracks, sheets of ice or mud holes, depending on the season, linked each town with the next. Each would start and finish at a green, the central focus of a town, then and now. One of the most attractive, and historic, is Litchfield's.

Falls Village has found itself one of several towns removed from the "beaten path," surviving with obvious spirit.

Norfolk serves as a northern outpost as well as tireless host to the creative arts, particularly music. The serene triangle of green serves as one of many stages.

Serenity and snow can bring to mind only one scene in Bethlehem.

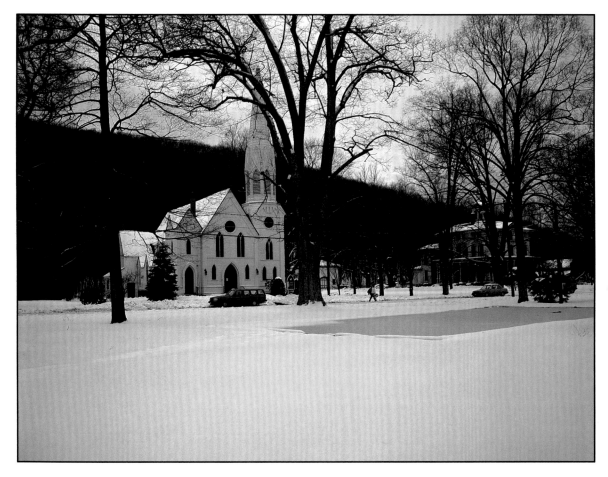

The snow-covered green at Pine Meadow sustains a small rink, when cold enough, and its own sense of community in spite of being a stone's throw from New Hartford.

In Washington the green turns gold and pink in season and maintains a quiet remove from the bustle of the Depot down the hill.

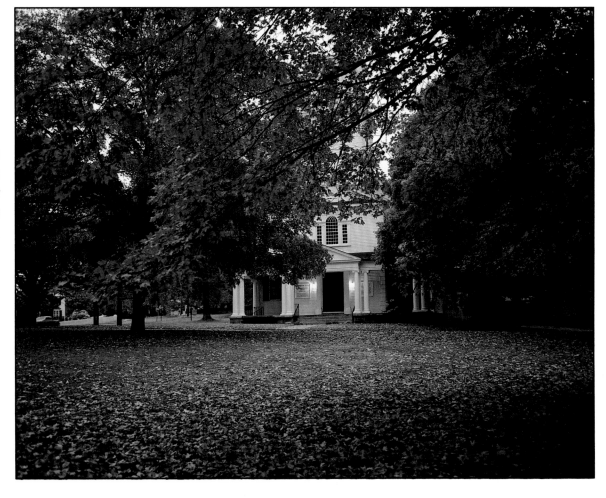

Each town would seem to have its monument to faith and remembrance. Here in Taconic, a town that awakens nowadays only in summer, stands a marker for a church not that long departed from this quiet autumn scene.

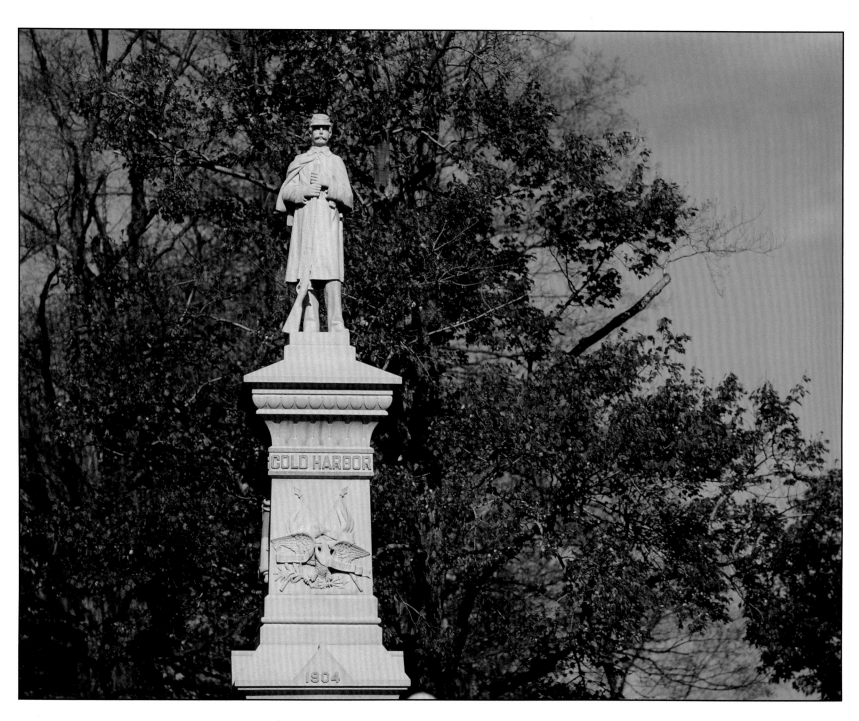

Winsted's memory turns dramaticly back to the Civil War.

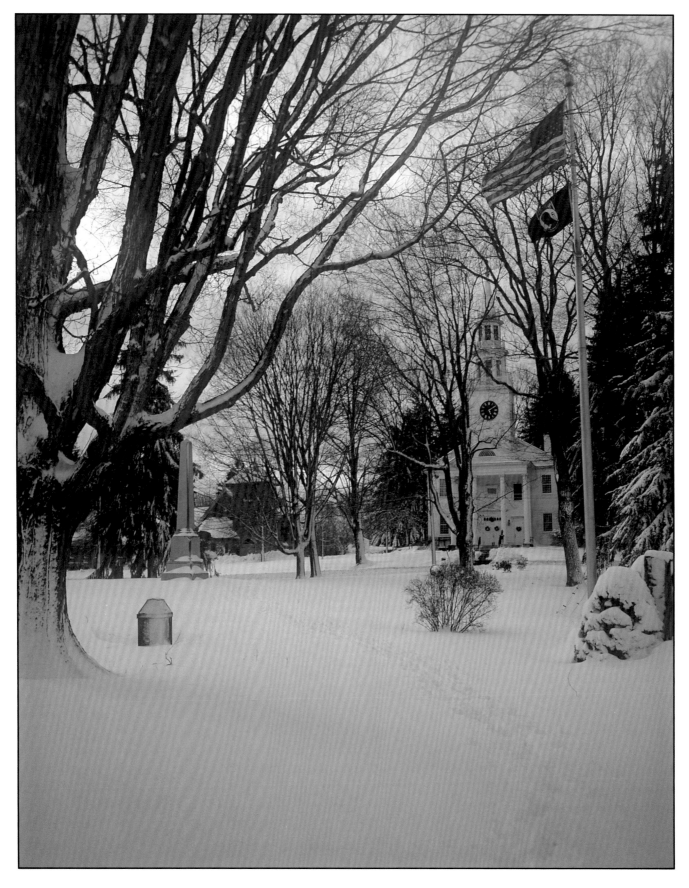

Often the raising of flags is eloquence enough, as here in Norfolk . . .

*. . . and here in the
Depot in Washington.*

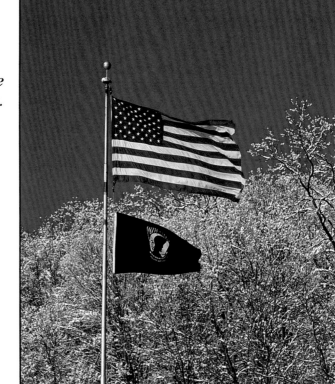

One community that speaks loudly and proudly
of its military participants is New Milford, with
this vintage reminder of the cold steel needed to
prosecute successful campaigns.

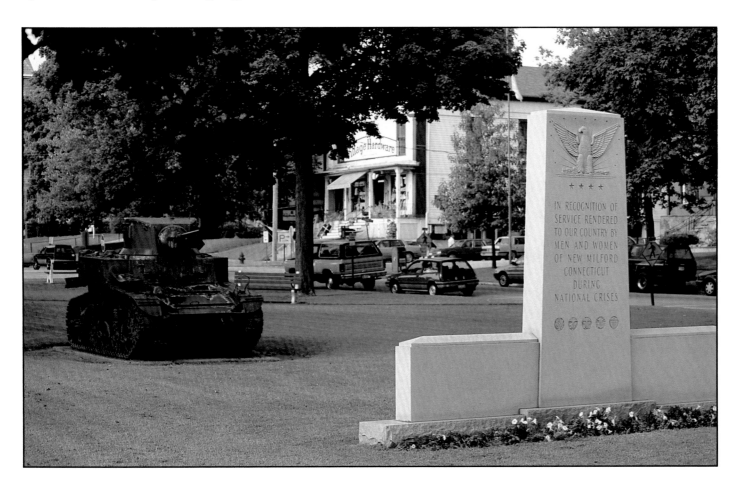

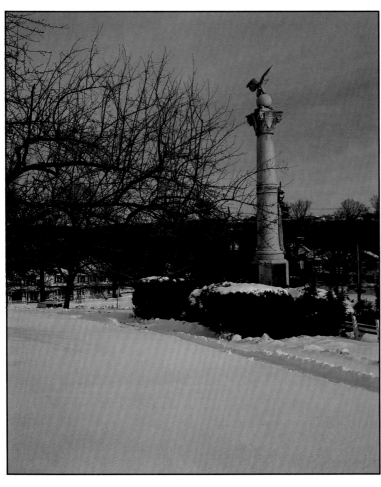

Watertown offers a lofty tribute to her fallen, far away.

While across the road this quiet plaque serves its high purpose in effective counter point.

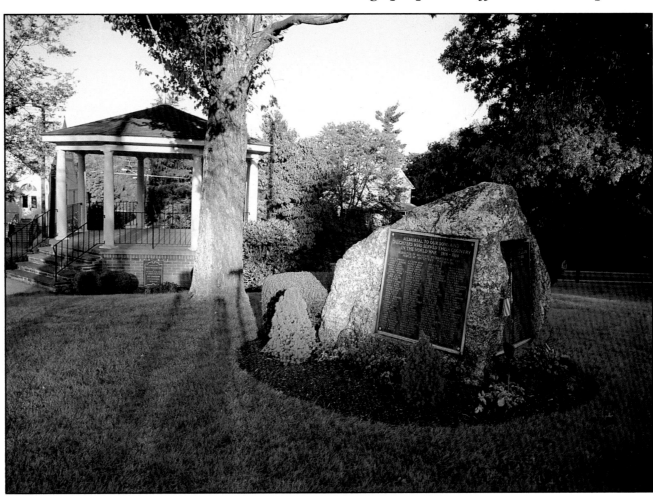

Where stone can speak in volumes, Center Brook, just east of Colebrook, has created an encyclopedia of commentary.

The state flower, mountain laurel, returns each spring to dot the landscape, as here near Harwinton, with its hardy reminder of Persephone's fate.

While the rhododendron is not native to New England, it has taken to the acid soils and well watered slopes of the region with great ease.

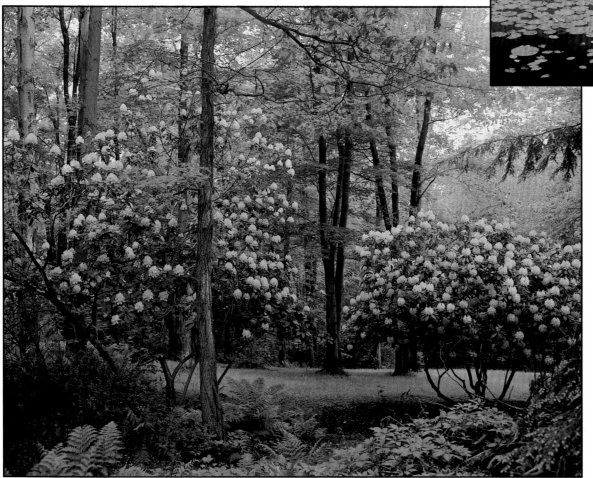

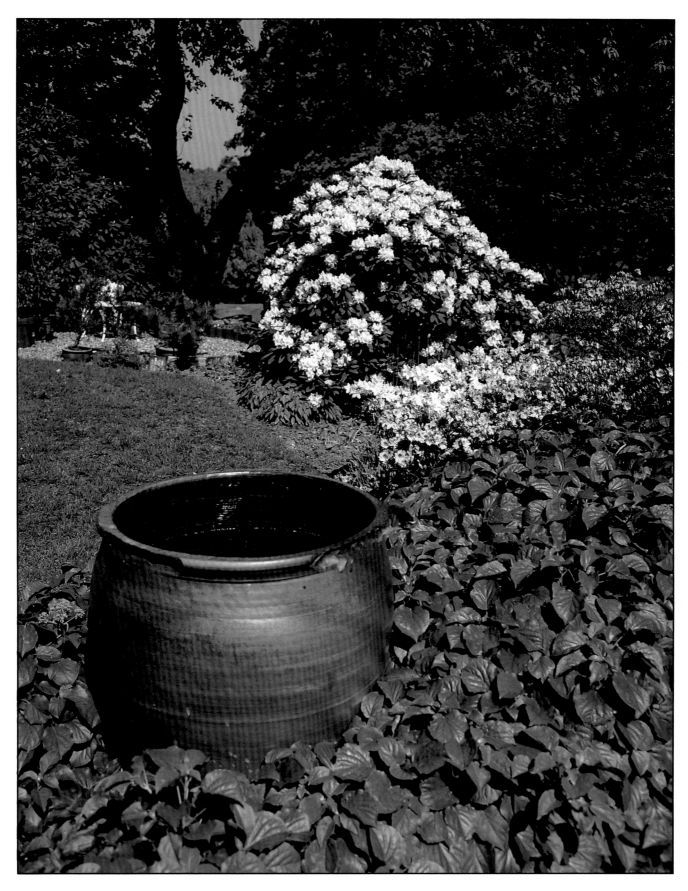

Many hybrid strains reward the diligent gardener and add elegance to any part of a landscape.

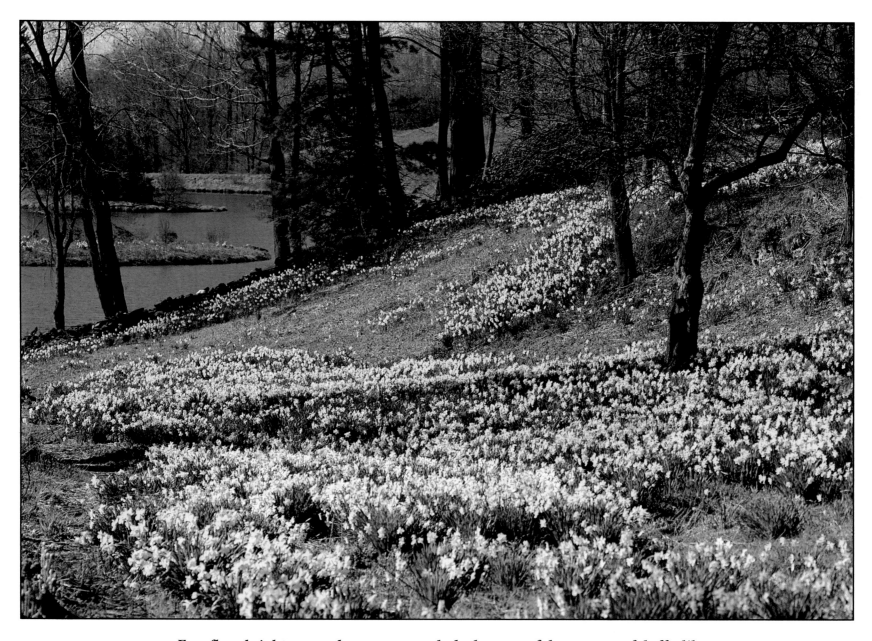

Few floral sights anywhere can match the beauty of these acres of daffodils in Northfield, planted by a benign soul for us all to wonder at.

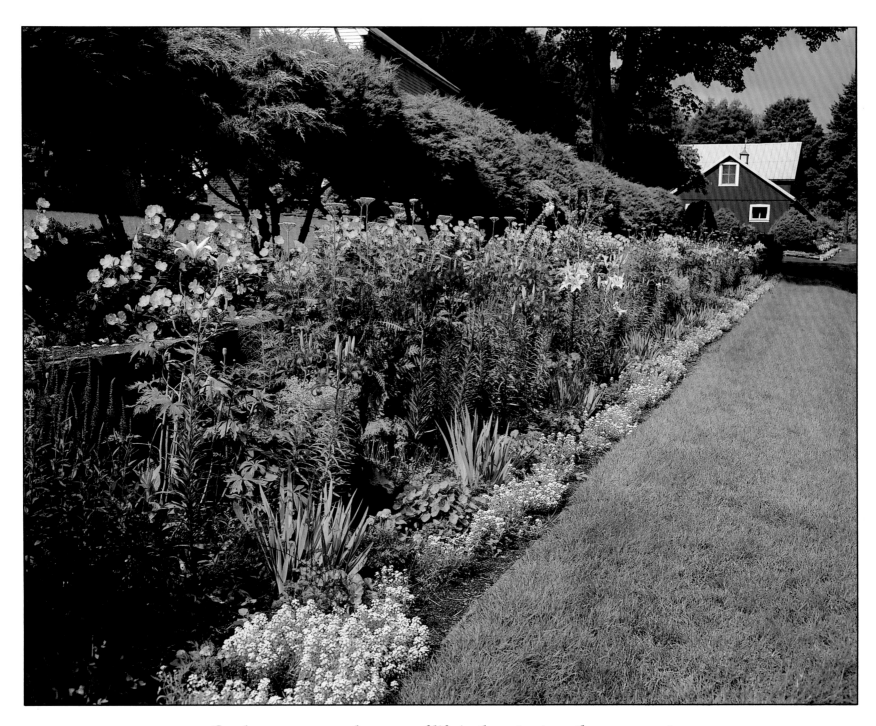

Gardens are as much a way of life in these parts as they are most anywhere. Many are out of the way, private sanctuaries and personal statements. But there are some of highly visible nature and well deserved acclaim, such as these between Woodbury and Washington.

*For travellers through Roxbury, these lovely plantings encourage a
full stop by Weller's Bridge and Rocky Mountain Roads.*

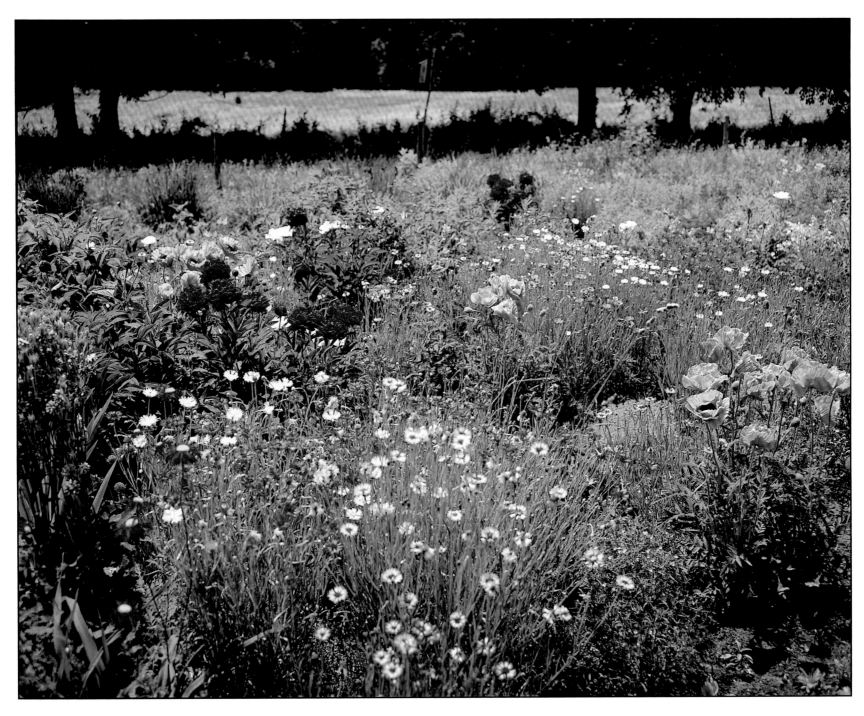

There are gardens, again in Roxbury, that roam across the landscape in glad abandon.

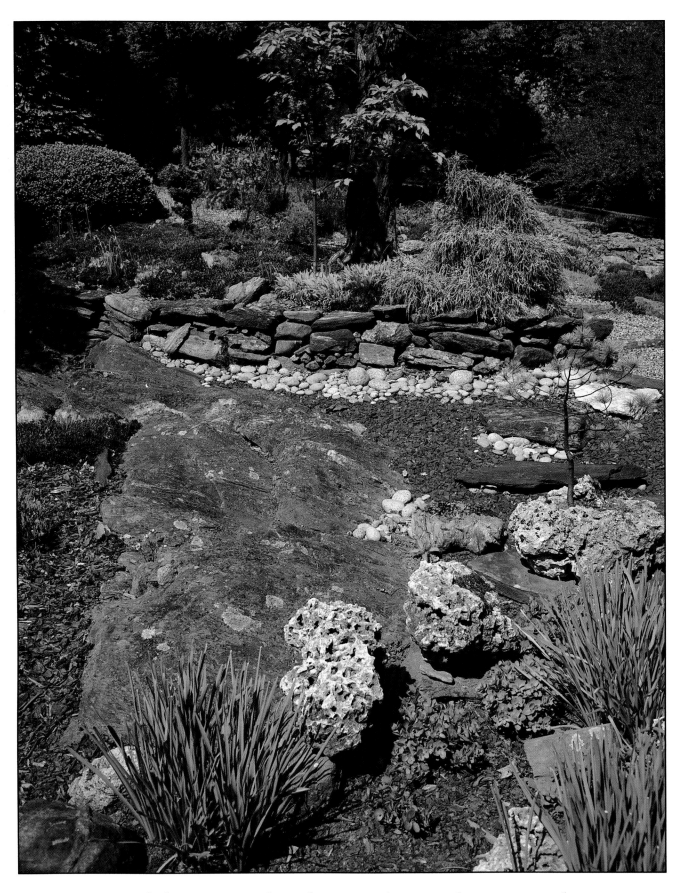

And there are gardens that serve introspection more, and reflection, that draw the eye inward to delight in the delicate.

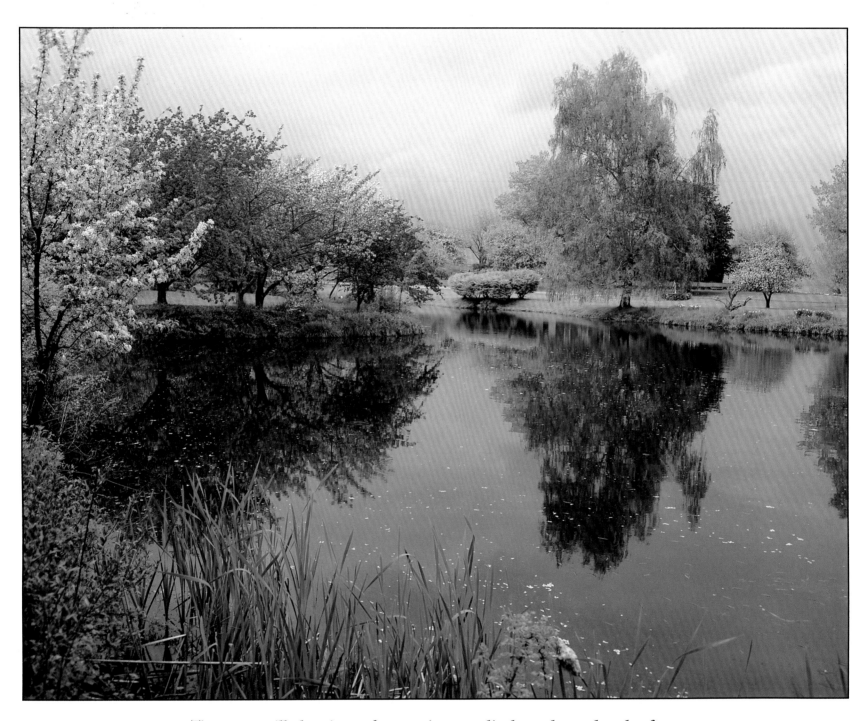

There are still plantings of nature's great displays, the orchards of our dreams, the endless rows of boughs laden first with flowers then fruit.

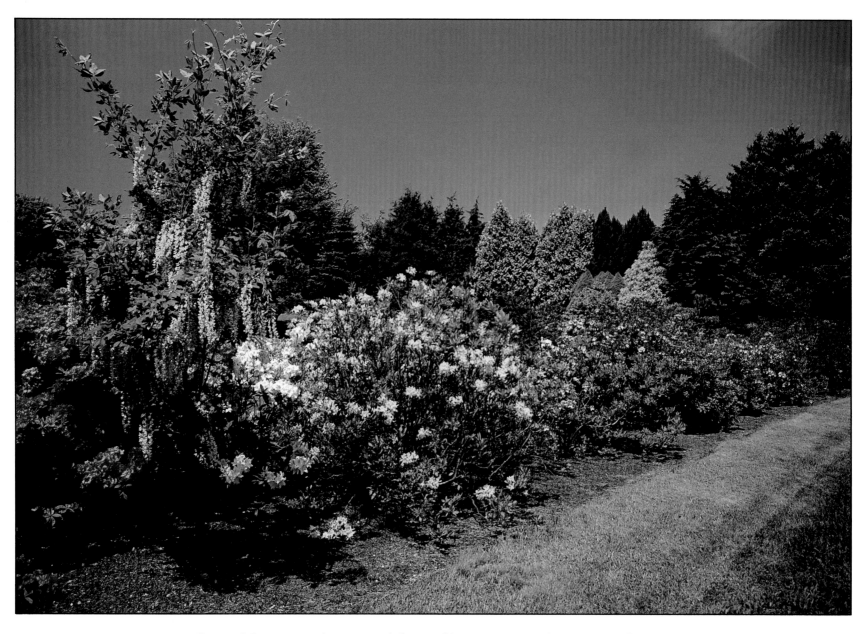

One of the county's most celebrated businesses is the source of many a colorful planting. Just south of Litchfield, the White Flower Farm is the destination of many a devoted pilgrim.

Flowers and remembrance can quickly bring to mind the quiet repositories of our past, the churchyards all around us. On the verge of abandon, the Allentown cemetery, south of Plymouth, prepares for winter.

Judea Cemetery (Washington was known as Judea before George came along) plays host to a colorful grace note by an early stone.

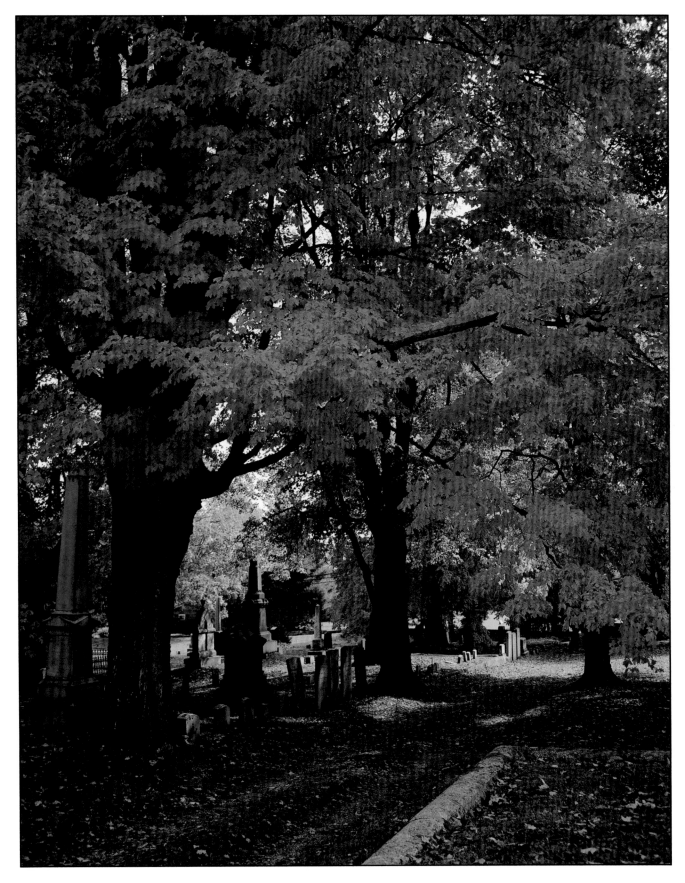

Trees often soar protectively above burial grounds, shedding color and giving shade, as here in Goshen.

At other times, the protective cover of a tree may come to be encroachment, as here in East Plymouth. But call it devotion.

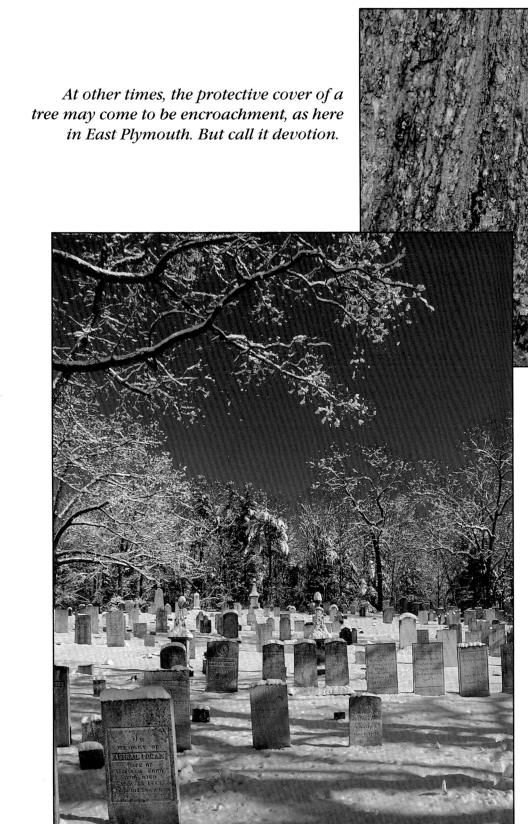

Stillness after a snowfall in a churchyard.

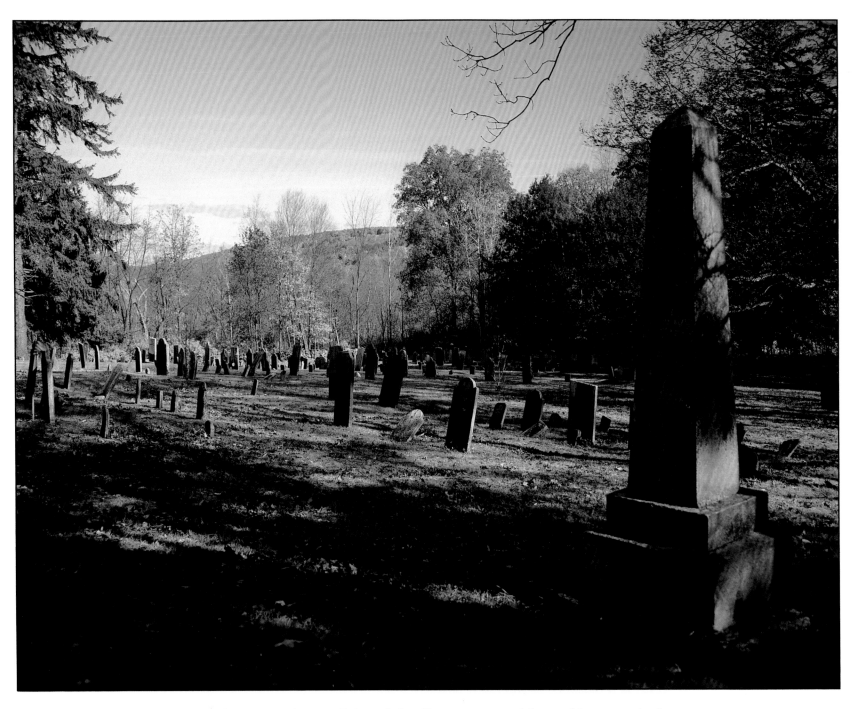

Shadows are the traditional dwellers at graveside, and here a windy autumn afternoon lends the perfect light to Gallows Hill, south of New Milford.

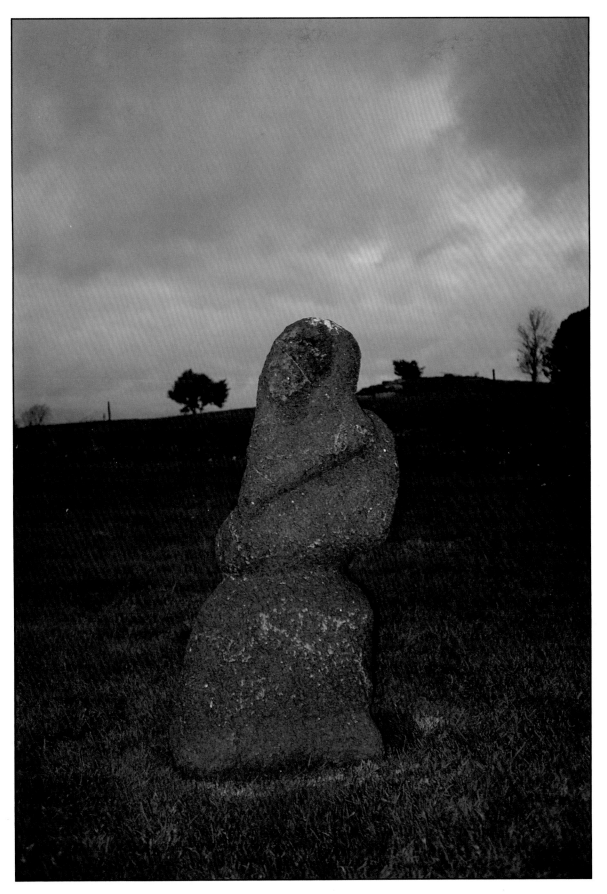

No mention of stone and remembrance in the county should exclude this remarkable find in West Morris. Of uncertain origin, the timeless brooding of its presence high on a hill overlooking Bantam Lake is quite haunting.

History abounds, scattered, collected, with us and gone. As saviours and repositories of what remains, our historical societies deserve high praise. Their locations alone can be of great reward. The Cornwall Historical Society building is one such case. With the large, central chimney and High Victorian embellishments, the range in styles is considerable.

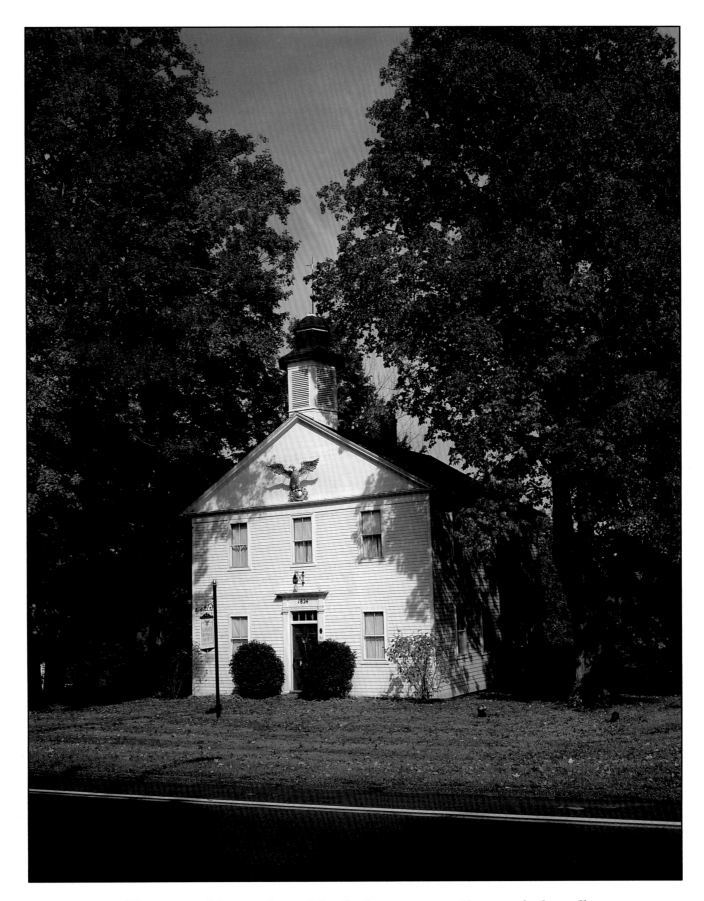

This venerable member of the Goshen community sounds the call to learning from its tower, if only figuratively these days.

We are all encouraged to contact historical societies, just as all are welcome at most of the parks, nature reserves and sanctuaries that virtually cover the map.

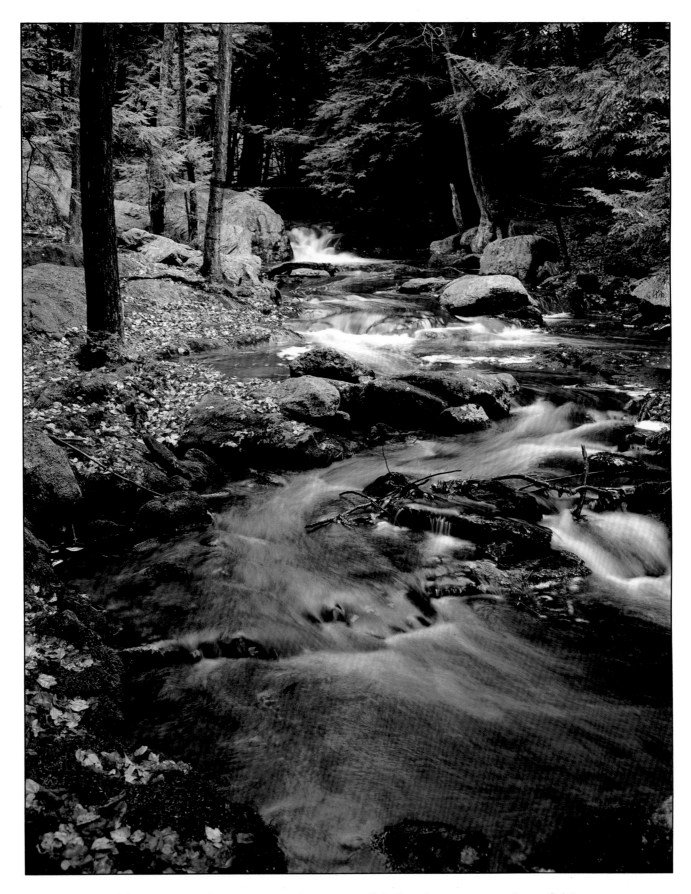

The Nature Conservancy is responsible for the preservation of this wild and truly beautiful site. It is found south of Plymouth, near the county border, and is known as Buttermilk Falls.

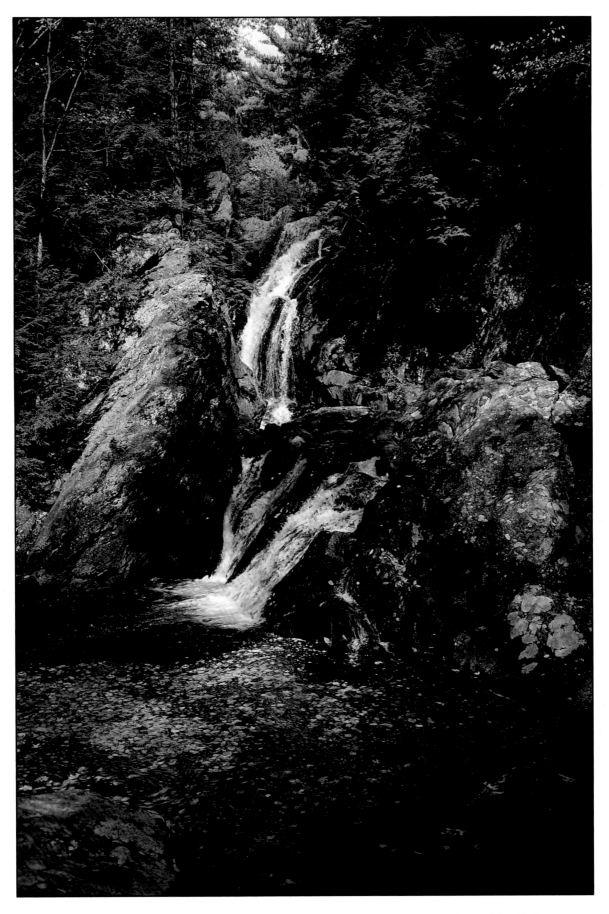

On another boundary, shared by Massachusetts north of Norfolk,
Campbell Falls State Park rewards the off-track traveller.

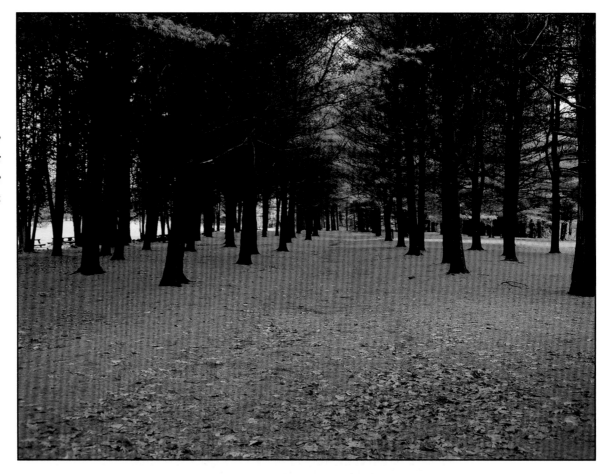

Back in the eastern part of the county, People's Forest offers access to a long stretch of the Farmington River, and such pine stands as this.

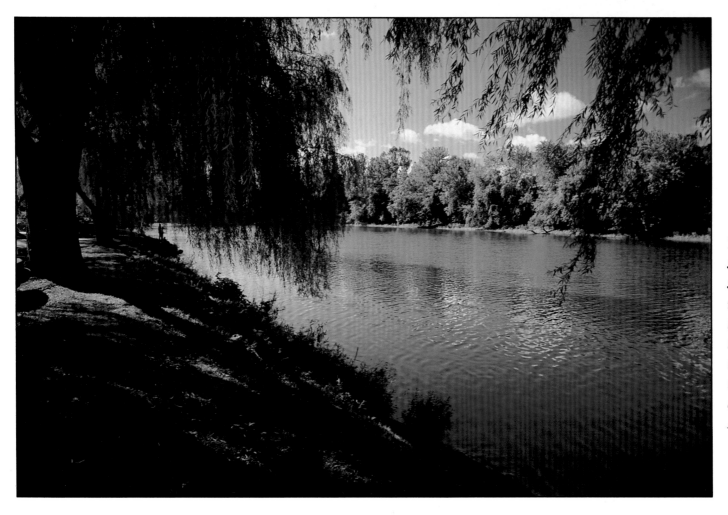

There are stretches of most streams and rivers that lend themselves gladly to the gentle indulgence of a tossed lure, such as here in New Milford.

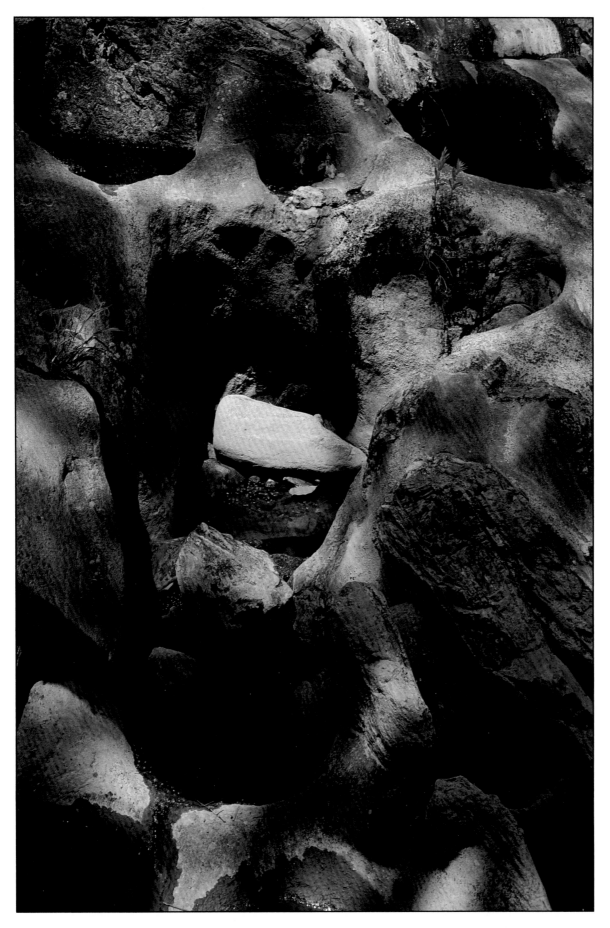

There is a portion of the Housatonic River, at Bull's Bridge, that is diverted at times to reveal rocks of primordial look where fish elsewise cavort.

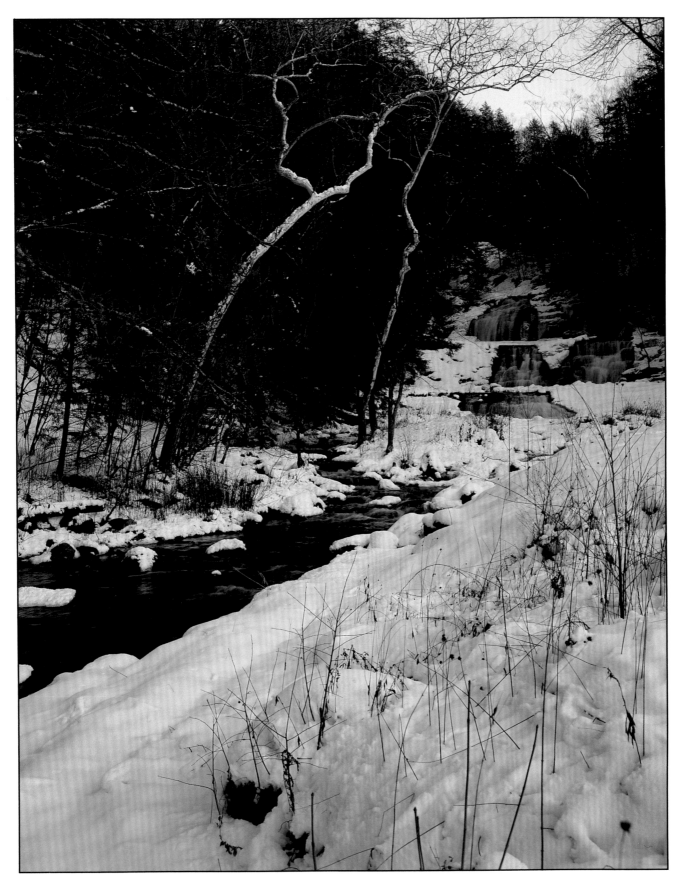

*Among the most popular of our parks remains that at Kent Falls.
Grandly impressive and readily accessible, they draw admirers
from near and far.*

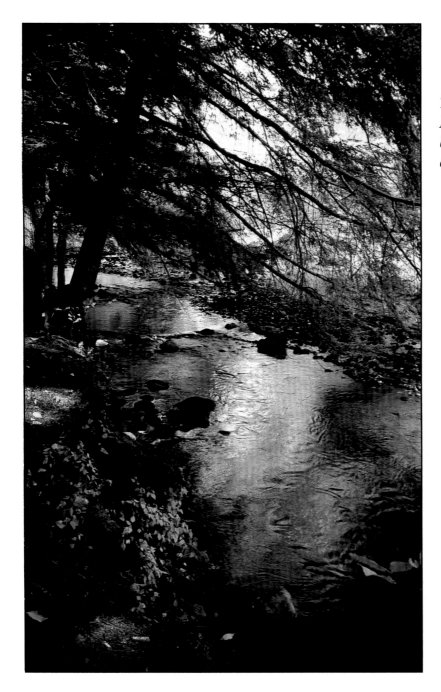

This quiet-running brook, imaginatively named Purgatory, runs through Black Rock State Park, between Watertown and Thomaston. A haven is carefully preserved.

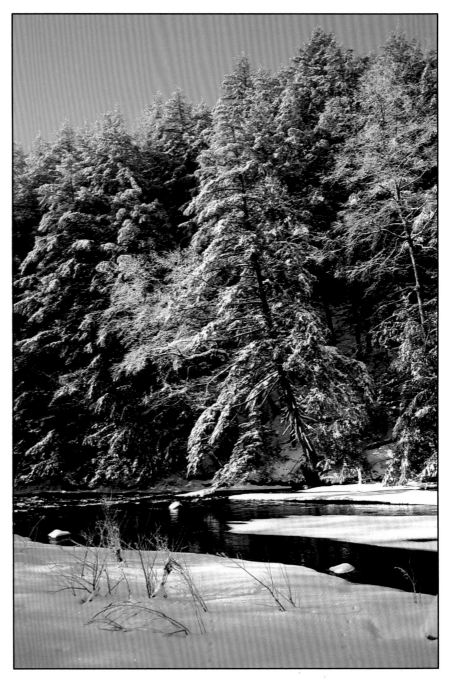

Steep Rock Park, bordering a wild and scenic stretch of the Shepaug River in Washington, remains protected for area residents and offers a haven for many species of wildlife.

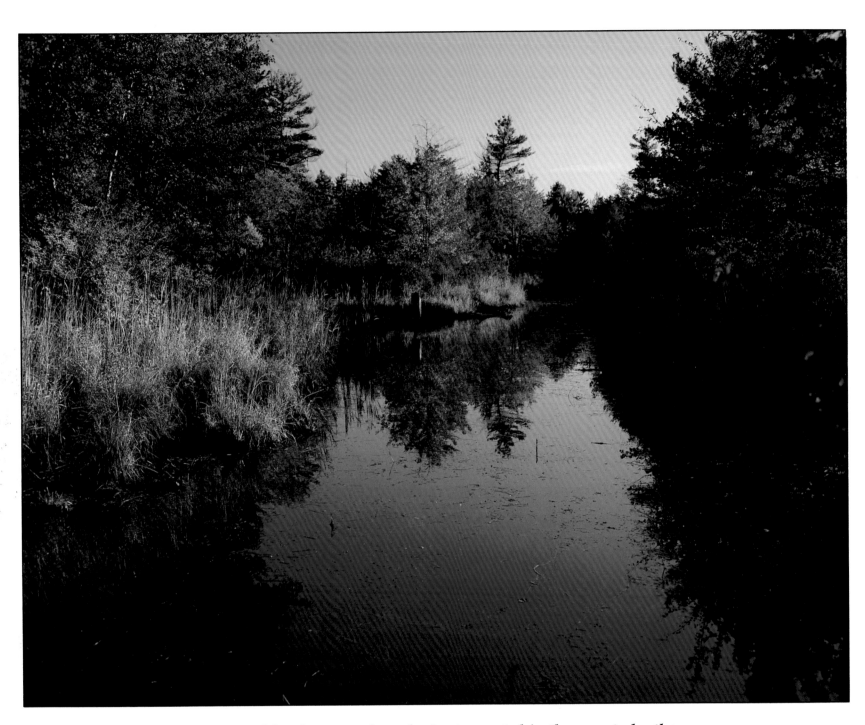

Protected lands are perhaps best represented in the county by the White Memorial Conservation Center, between Litchfield and Bantam. An active year-round program keeps the public informed of environmental issues and helps to promote wildlife preservation, as it has since the 1920's.

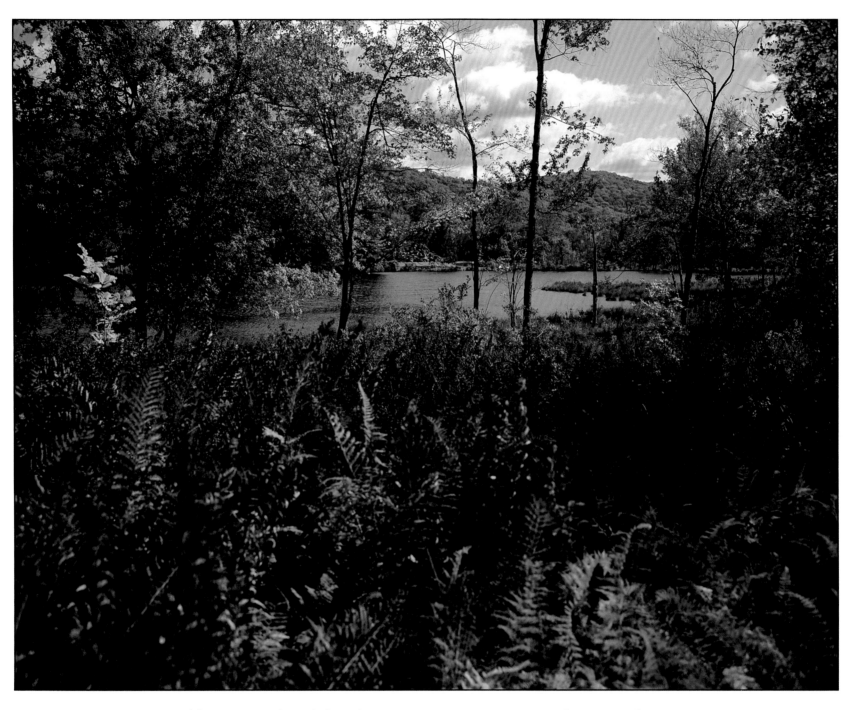

The National Audubon Society maintains a treasured presence here as well. Its programs are as world famous, as its profile at the Miles Sanctuary in Sharon is low key.

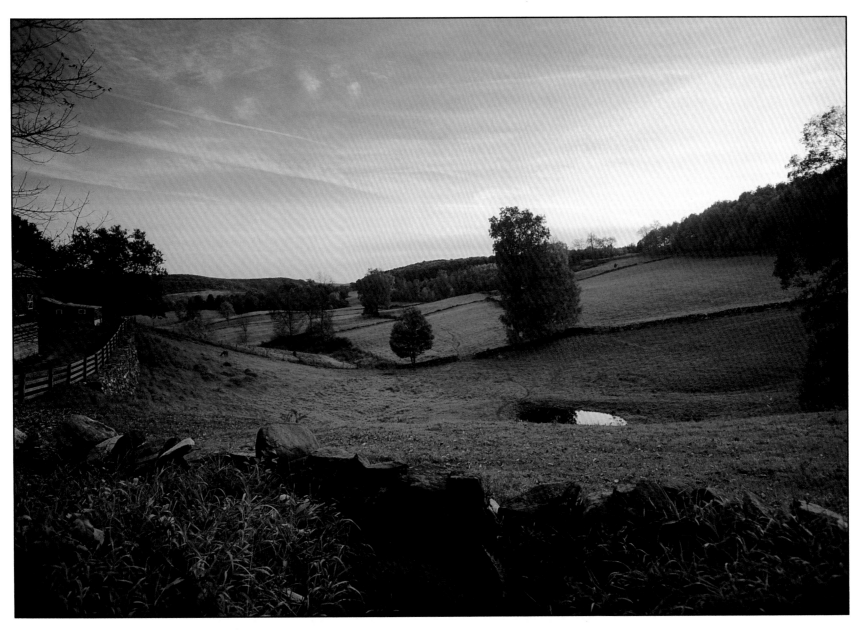

There remains room enough here only for a final tour of the back roads, where farmland rolls . . .

. . . where light and shadow fall . . .

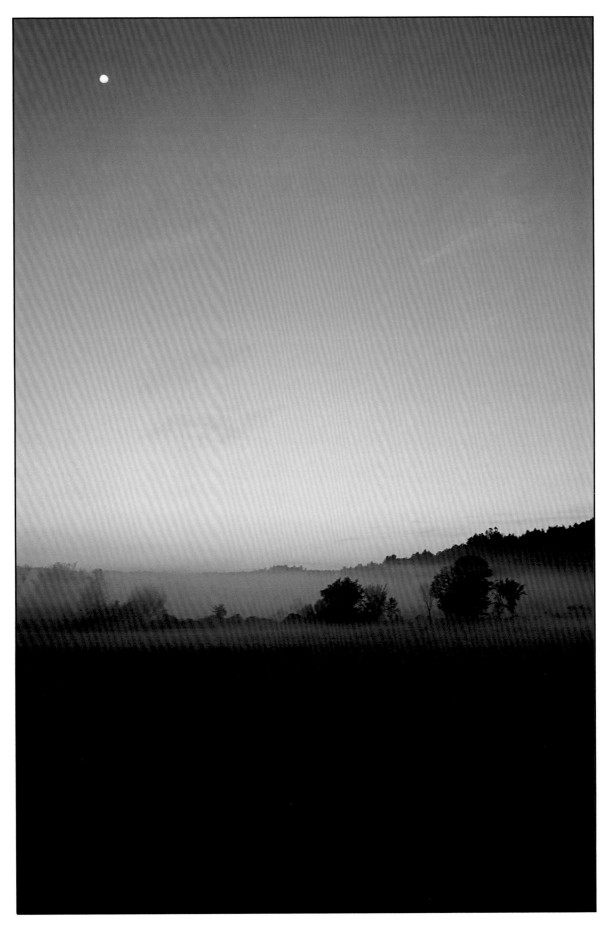

. . . where mist and moon conspire . . .

. . . where fields and fog may cast their spell . . .